IMAGES
of America

CONIFER

To Jon and Amy
Sommer

John Steinle

7/13/19

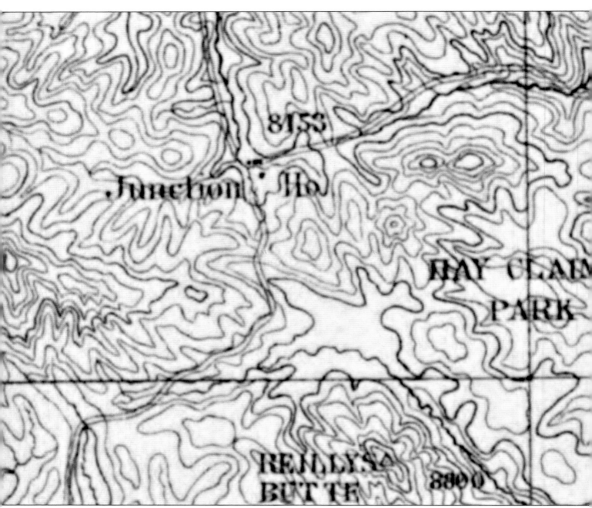

The 1877 *Geological and Geographical Atlas of Colorado and Portions of Adjacent Territory* by F.V. Hayden labels the future Conifer community simply as "Junction." The intersection of the two toll roads is clearly shown. The notation beside it, "Ho," means "hotel." (Courtesy Evergreen Mountain Area Historical Society.)

IMAGES
of America

CONIFER

John Steinle

ARCADIA
PUBLISHING

Published by Arcadia Publishing
Charleston, South Carolina

Printed in the United States of America

Library of Congress Control Number: 2018956617

For all general information, please contact Arcadia Publishing:
Telephone 843-853-2070
Fax 843-853-0044
E-mail sales@arcadiapublishing.com
For customer service and orders:
Toll-Free 1-888-313-2665

Visit us on the Internet at www.arcadiapublishing.com

This book is dedicated to the Conifer Historical Society and Museum members for their leadership in preserving Conifer's history and their enormous help in making this book possible.

Contents

Acknowledgments

First and foremost, Suzi and Don Morris have been tireless in their quest for photographs and information about Conifer's history. Many Conifer Historical Society and Museum members also helped in researching and reviewing, including Susan Switzer, Carla Mink, Lin Rudy, Cindy Miller, Kathy Glenn, Donna Long Beck, Betty Fields Long, Bob Kuehster, and Yvonne Ludwig.

Tim Sandsmark, Jefferson County Open Space education supervisor, took expert Conifer photographs.

Richard and Bonnie Scudder, experts on Elk Creek and Staunton State Park history, generously shared their superb photographs.

Coi Drummond-Gehrig, digital image collection administrator of the Denver Public Library Western History Department, gave invaluable guidance.

Sarah Gilmor, Aaron Marcus, and Chelsea Stone at History Colorado's Stephen H. Hart Library & Research Center assisted in reproducing photographs.

Elaine Hayden, president of Evergreen Mountain Area Historical Society, and the board of the society generously allowed use of the society's photographs.

Tom Fildey and Michael Hicks of Evergreen Newspapers were vital to my ability to locate Conifer images.

Many local families, including the Kuehsters, Longs, Fields, Wilhelms, Woods, and Curriers, permitted reproduction of their cherished family images.

Yvonne Ludwig guided Tim Sandsmark and me through the Pleasant Park Cemetery and revealed her family's history.

Donna Prescott, administrator of Conifer Community Church, helped locate photographs of the church's activities.

Lori Frease, office administrator for Conifer Area Chamber of Commerce, helped find photographs of the chamber's activities.

Sara Johnson and Melanie Nucholls of the Mountain Resource Center found excellent photographs of the center's activities and allowed their use.

Lauren Hunt, Venue Theater upper elementary director and choreographer, guided me toward images of the theater's productions.

Tom Carby, Donna Jack, and Ron Lewis, members of Conifer Kiwanis, shared their photographs and expertise.

Ilene Raynes of the University of Colorado Earth Sciences and Map Library searched the library to find maps showing early Conifer.

The Pleasant Park Grange members gave valuable suggestions.

And finally, my wife, Mary, gave me her unstinting support and advice, as always.

Many images in this volume appear courtesy of Conifer Historical Society and Museum (CHSM) and Evergreen Mountain Area Historical Society (EMAHS).

INTRODUCTION

That afternoon I cooked, while fog rolled around the pine trees, covering each pine needle with frost. What a luxurious life I was living! And the next morning to see a fairyland of crystal twinkling in sunlight made complete my feeling of living in wealth. The golden sparkle of each pine needle did not last long under the heat of the Colorado sun. But then, all wealth is fleeting. And this wealth at least had the distinction of being lovely while it lasted. It was unique, also, in that there was beauty left even after the extravagant richness had gone.

—Hermina Gertrude Kilgore
Rough Road in the Rockies

Hermina Kilgore's memories center on the reason why the Conifer area has always drawn people to it: the overwhelming natural beauty of the Rocky Mountain foothills. At about 8,000 feet in elevation, Conifer remains an unincorporated community with no mayor, city government, or police force.

The first pathways through today's Conifer led the Ute, Cheyenne, and Arapaho to favorable hunting grounds. The Ute Trail ran along South Turkey Creek through Conifer; for generations, the Utes followed it from their home in the mountains to the plains to hunt buffalo.

Then came the great upheaval: the Colorado Gold Rush of 1859. Suddenly, lands occupied by Native Americans and only a few fur traders or trappers were overrun by tens of thousands of gold seekers aiming to strike it rich.

Soon, toll roads were constructed by entrepreneurs who amassed the funding and obtained the charters needed to build the roads. By 1860, two important toll roads met at the location known as Bradford Junction, or on some maps simply Junction. The Mount Vernon Toll Road ran from Denver to the town of Mount Vernon (site of today's Matthews-Winters Park) then up Mount Vernon Canyon (today's Interstate 70 route). At Bergen's Ranche (now Bergen Park), it turned south and met the Bradford Toll Road in the area now known as Conifer. Maj. Robert Bradford's toll road ran from Denver through the location of Bradford's home in present-day Ken-Caryl Ranch up steep hills to join the Mount Vernon Road. Then both roads ran roughly along the Highway 285 corridor out to the gold mining communities of Fairplay and Tarryall.

At Bradford Junction, a tiny community began to grow, and another wagon road, the Turkey Creek Wagon Road, eventually also led there. Soon a hotel at the junction offered rest for weary travelers, and at some important point during the Civil War, a well was dug there, too. With this location as a nucleus, the tiny community was known successively as Bradford Junction, Hutchinson, and finally Conifer.

Soon other small communities began to grow within the unincorporated Conifer area. Many had their own post offices, schools, stores, and sawmills. Ranching and farming became the economic mainstays. Enormous crops of hay supplied feed for draft animals. Root crops were also big business, as were Christmas trees and lumber. Many ranchers had private sawmills on their property to harvest the forests of pine and fir nearby. Along newly built roads, communities such as Pleasant Park, Medlen, Brownsville, Shaffer's Crossing, and others developed.

A special boost to the local economy came in the 1890s, when the US government went on the gold standard, abandoning the use of silver to back its currency. This resulted in a second gold rush and the opening of several gold mines, including the Anna L., Sampson, Ruth, and Two Jacks mines. Two communities, Critchell and Phillipsburg, grew up around these mining operations. After a short while, the mines played out. Though Critchell still survives as a local neighborhood, little trace of Phillipsburg can be found today.

The Denver, South Park & Pacific Railroad (later known as the Colorado & Southern) fostered the growth of summer cabin communities along the South Platte River such as Foxton and South Platte, sustained by tourism, fishing, and relaxation.

By 1910, the Colorado Business Directory listed a dozen businesses in Conifer, including general stores, a post office, sawmills, a music teacher, a stagecoach line, a summer resort, and two churches. Ten years later the population jumped to 150, with the former businesses being joined by painters and paperhangers.

A high-profile addition to the Conifer community came in 1918 with the sale of the old junction area to J.J. Mullen, nephew of flour milling magnate J.K. Mullen. Construction began on three structures at the site, including the famous Yellow Barn, to this day a local landmark. The barn and two other buildings were assembled from kits sold by the Gordon-Vantine Company.

The Mullen family contributed to the Conifer community by leasing land for a new school in 1923. Built by residents, the Conifer Junction School replaced earlier one-room schoolhouses and became a focus for dances, parties, socials, and other community celebrations. It remains a beloved landmark in Conifer for generations of former schoolchildren.

During the Great Depression, local ranchers embraced a new source of revenue that became common across the area: fox farming. Fox pelts—especially silver fox—brought huge prices on the international fur market. Unfortunately, after World War II, the bottom fell out of the fox pelt market due to the switch to mink in the fashion industry. By the early 1960s, the local fox farms had all been phased out.

With the Denver Ordnance Plant and other war industries at full blast, the population of Jefferson County increased by more than 80 percent during World War II. Postwar economic prosperity, the GI Bill encouraging new home construction, and the baby boom led to an even greater expansion and the growth of Jefferson County suburbs. By 1950, the Conifer population reached 408 in the Junction Precinct, the area around the original toll road junction. The straightening and improvement of Highway 285 that year undoubtedly contributed to Conifer's growth in the following decades.

New schools resulted from the growth in population, beginning with West Jefferson Elementary School in 1955. West Jefferson Junior High School followed in 1974, becoming West Jefferson Middle School in 1996. That same year, a large and beautiful Conifer High School opened. Conifer students no longer had to go to Evergreen High School for secondary instruction.

By 1972, ever-increasing suburban sprawl alarmed many Jefferson County residents concerned about the loss of ranchland and open spaces. Sixty percent of voters approved a half-percent sales tax to acquire scenically and culturally significant properties. Jefferson County Open Space was born. Today, Open Space owns or controls more than 55,000 acres of land, including Flying J Ranch Park, Meyer Ranch Park, Beaver Ranch, and Reynolds Park in the Conifer area. Multiple Denver Mountain Parks sites also surround Conifer, while to the south lies the vast Pike National Forest. In 2013, Staunton State Park opened along Elk Creek south of Conifer. The 3,400-acre park with spectacular rock formations features a network of magnificent trails.

In the 1990s and early 2000s, commercial development began to keep pace with the increase in population. New shopping areas were constructed, including the King Soopers complex in Aspen Park and the Conifer Village Center complex just to the south along Highway 285. To the growing populace of Conifer, these new retail developments offered shopping for food and household necessities, pharmacies, restaurants, and two small theaters.

By 1990, the Conifer population was 11,427, and by 2009, it had zoomed upward to 19,683. Currently, almost 68 percent of Conifer residents work in white-collar jobs, while only 0.4 percent are involved in farming or ranching. This is a huge contrast to Conifer's traditional overwhelmingly agricultural means of livelihood.

With the agricultural way of life passing away, and many members of longtime families passing with it, Conifer Historical Society and Museum was formed by concerned residents in 2009. In 2012, the Jefferson County School District donated the old Conifer Junction School, built in 1923, and several surrounding buildings to CHSM. Since then, CHSM volunteers have renovated the school building and presented a very successful continuing series of programs focusing on the history, lore, and legends of Conifer and the surrounding area.

With the help of CHSM, the past seems to have a bright future in Conifer, Colorado.

One

THE LAND AND
FIRST PEOPLE

Conifer, in western Jefferson County, is surrounded by the valleys of North and South Turkey Creeks, Elk Creek, and the South Platte River. Added to these waterways are numerous springs throughout the area. Grassy mountain meadows made an ideal setting for the ranching and agricultural ways of life that predominated until recently.

Conifer is also ringed by granitic mountain peaks, including Berrian Mountain, Doublehead Mountain, Legault Mountain, Conifer Mountain, Riley Peak, the Lion's Head formation, and Black Mountain, the tallest at 10,846 feet.

Wildlife abounds in the area, including elk, mule deer, black bear, mountain lion, marmot, and bighorn sheep. Fly fishing is popular and yields cutthroat, rainbow, brown, and brook trout.

People have harvested these resources since prehistoric times. By the time of the Colorado Gold Rush, the Ute, Cheyenne, and Arapaho were the dominant native tribes in the region. Usually relationships were friendly, though legend says that neighbors of the McIntyre family were massacred by Sioux. Ute chiefs Colorow and Washington were well known to early settlers. The trails blazed by the Utes leading to and from the mountains were often adapted, improved, and used as roadways.

Though no major mines operated in the area during the first gold rush of 1859–1860, in the 1890s, the government's adoption of the gold standard sparked a second gold rush. In the Conifer area, gold and other minerals were mined for perhaps a decade. Many ranching families also dug "glory holes" on their property and ran small mining operations. Unfortunately, the veins of ore played out, the mines were abandoned, and the dreams of riches faded away.

Beginning in the early 1900s with the creation of the Denver Mountain Parks system, the outstanding scenic resources of the Conifer area have been preserved. In the 1970s, Jefferson County Open Space also added magnificent parks, while the latest addition to protected land, Staunton State Park, is one of the gems of the Colorado State Parks system.

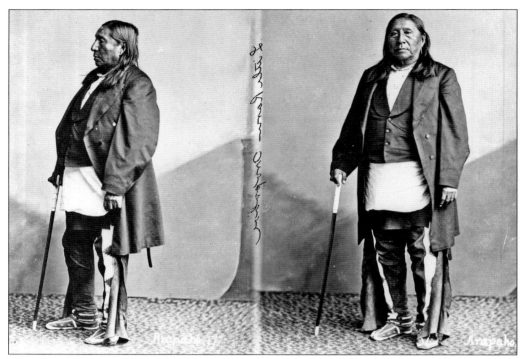

Arapaho chief Little Raven, also known as Chief Hosa, poses in a mixture of clothing types for this portrait. Little Raven was influential in promoting peace along the Western frontier, signing the Treaty of the Little Arkansas in 1865 and the Medicine Lodge Treaty of 1867, which forced the Southern Cheyenne and Arapaho onto a reservation in Oklahoma. (Courtesy History Colorado, scan 10041558.)

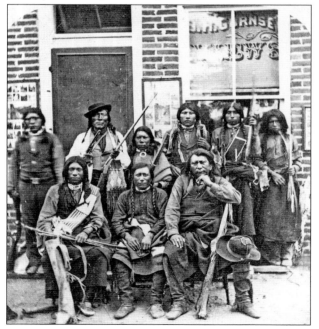

Chief Colorow of the Moache band of the Ute people sits at far right in the first row in this photograph with members of his band. Colorow was well known to many early settlers in Jefferson County and the surrounding area. He was noted for his insatiable love of biscuits. Generally peaceful and helpful, Colorow could be fierce when reacting to injustice or dishonesty. (Courtesy History Colorado, scan 10039967.)

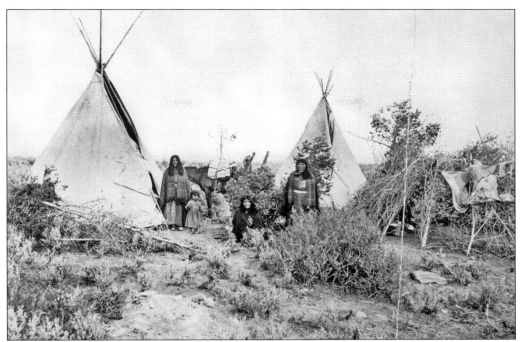

This 1899 photograph shows a Ute camp in southern Colorado. The tipis, brush shelters, racks for drying meat, and other camp items were typical of Ute encampments around the Conifer area. (Courtesy History Colorado, scan 10026215.)

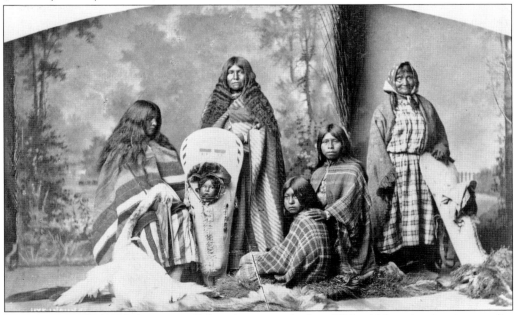

Ute women with their babies in cradleboards pose in the late 1800s. Although taken in a studio, this photograph shows the women using the traditional Ute way of carrying their infant children. However, by then, the traditional buckskin and elk skin clothing had been replaced by cloth dresses. (Courtesy History Colorado, scan 10033006.)

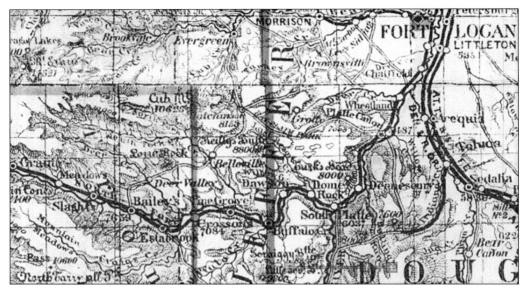

The 1889 "Nell's Topographical Map of Colorado" clearly shows the town of Hutchinson, later renamed Conifer, almost directly south of the recently named community of Evergreen. Denver is about 35 miles to the northeast. (Courtesy University of Colorado Earth Sciences and Map Library.)

Doublehead Mountain, with its distinctive twin peaks and radio tower, could be called the gateway to the Conifer area as motorists drive south on Highway 285. The mountain rises to about 8,900 feet, and much of the terrain is part of the Denver Mountain Parks system. (Photograph by Tim Sandsmark.)

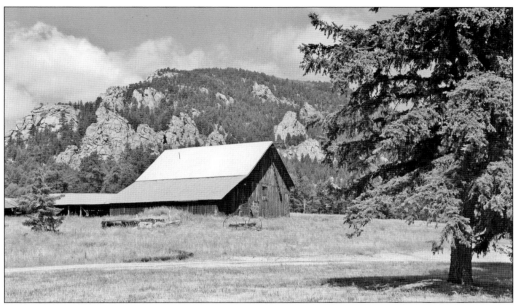

Berrian Mountain forms a northwestern boundary of sorts for Conifer. The 9,151-foot mountain is named after the Berrian (now spelled Berrien) ranching family, who created Centaur Ranch in the 1880s. Part of the Berrien family still lives on the original ranch property. Originally, the peak was named after prominent local rancher Duncan McIntyre. (Photograph by Tim Sandsmark.)

The Legault family, whose pioneer ranch was located nearby, gave their name to Legault Mountain. From 1941 to 1942, Covert "Hoppy" Hopkins, Loren Fender, and Otto Kuehster partnered to operate a ski lift and run on the north face of the mountain, complete with a warming hut. Skiers reached the top by holding a tow rope pulled by a Buick engine anchored to the mountain. Wartime gas rationing limited travel and ended the short-lived ski run. (Photograph by Tim Sandsmark.)

The tallest peak in the Conifer area at 10,846 feet, Black Mountain is the apex of a ridge stretching to the southeast from Mount Evans. The ridge separates the drainage area of Bear Creek to the north, running through Evergreen and Morrison, from Deer Creek and Elk Creek, flowing through the outskirts of Conifer. (Courtesy Richard and Bonnie Scudder.)

The Lion's Head formation is the most distinctive and unmistakable mountain in the Conifer area. The mountain, rising to 9,463 feet, is now part of Staunton State Park, and hiking trails lead to the summit, offering magnificent views of Elk Falls and the surrounding area. (Courtesy Richard and Bonnie Scudder.)

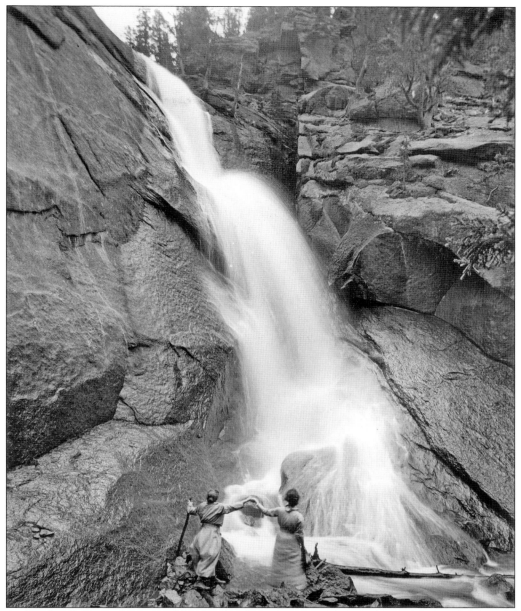

As Elk Creek flows over several levels of rock formations, it forms a beautiful waterfall known as Elk Falls. The falls have been a tourist destination for a very long time, as shown in this late 1800s or early 1900s photograph of two women holding hands there. (Courtesy Denver Public Library, Western History Department.)

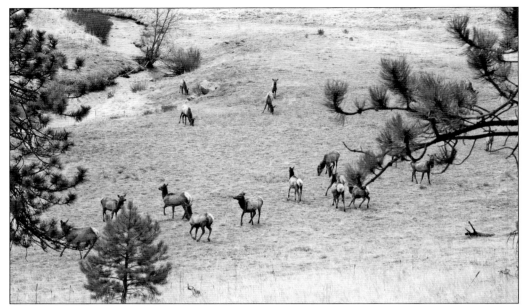

Elk Creek is aptly named, as shown by this photograph of the elk herds that graze on the grassy banks surrounding the waterway. Elk, once almost wiped out in the area, have proliferated throughout Conifer and Evergreen after being reintroduced from populations in Wyoming by the Colorado State Game and Fish Department in 1917. (Courtesy Richard and Bonnie Scudder.)

One of the most important early wagon roads in Jefferson County, the Elk Creek Road connected ranchers in the Elk Falls and Shaffer's Crossing area with the community of Pine Grove and the Denver, South Park & Pacific (later Colorado & Southern) Railroad. This connection was vital for ranchers marketing their livestock and produce. (Courtesy History Colorado, scan 10055100.)

This early 1900s photograph shows the picturesque rocky bed of Turkey Creek as it flows from its headwaters near Conifer. North and South Turkey Creek join together at the Twin Forks, then flow into Bear Creek Lake. (Courtesy History Colorado, scan 10055097.)

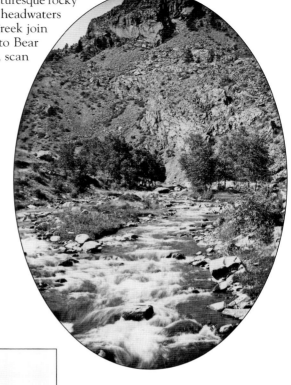

A rough wagon toll road led along Turkey Creek, eventually meeting with several other toll roads at Bradford Junction. The North and South Turkey Creek corridors spawned communities such as Brownsville and Grotto, which became ghost towns. (Courtesy History Colorado, scan 10055098.)

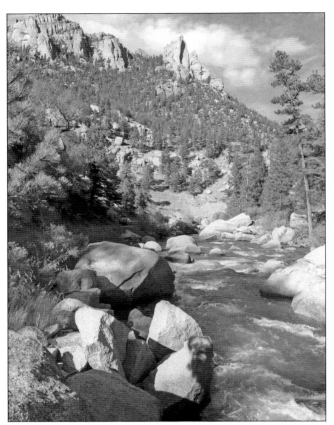

The South Platte River carved a beautiful canyon with numerous granite boulders and rock formations as it flowed into the Denver area. The river forms a southern edge of Conifer. (Photograph by Tim Sandsmark.)

The Denver, South Park & Pacific Railroad used the South Platte River canyon as a natural corridor to extend the railroad from Denver to the south. Eventually, it curved through South Park and over Boreas Pass before reaching Leadville and its silver mines. Foxton was one of several summer cabin communities that developed along the tracks. (Photograph by Tim Sandsmark.)

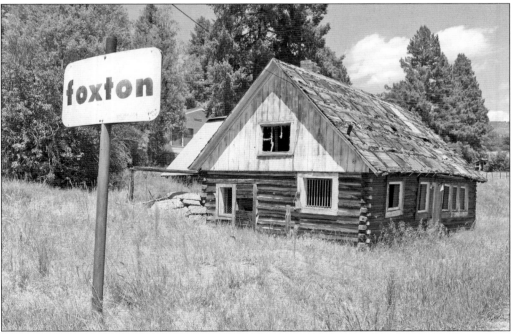

Starting in the early 1900s, the Reynolds family ran a dude ranch known as the Idle-Ease Ranch on their property along Foxton Road. Today it is part of the Jefferson County Open Space parks system, known as Reynolds Park. This magnificent view is from the Eagle's View Trail. (Photograph by Tim Sandsmark.)

The Kings Valley housing development climbs the slopes of Conifer Mountain, connecting to Highway 285 and the Conifer Mountain subdivision. Residents enjoy stunning views of Staunton State Park, and even Pike's Peak is visible almost 80 miles to the south. (Photograph by Tim Sandsmark.)

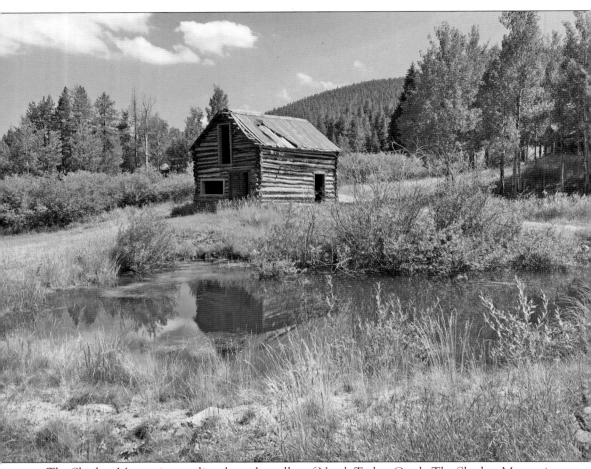

The Shadow Mountain area lies along the valley of North Turkey Creek. The Shadow Mountain Estates housing development dominates the area, but some reminders of earlier habitations remain, including this original Spicer cabin. The home was built around 1893, when the Spicer family purchased 320 acres near the creek. (Photograph by Tim Sandsmark.)

Two

THE JUNCTION

The great Colorado Gold Rush of 1859 brought thousands of prospectors seeking their fortune. But how would they reach the gold they sought? The answer was supplied by entrepreneurs who built toll roads. At the junction of two of these roads, the nucleus of a new community was born. The Mount Vernon Toll Road and Bradford Toll Road met at the location known as Bradford Junction.

A hotel was soon built at the junction, and a well was dug right at the crossroads. Legend has it that the well was completed just as word arrived of an important Civil War battle; it is still known as the Civil War Well.

Though the original hotel burned in 1878, another was soon built, along with a post office. The small community went through several name changes, including Bradford Junction, Hutchinson, and finally Conifer. By 1918, the Mullen family owned the junction-area ranch. They built the 5,000-square-foot Yellow Barn and several other buildings assembled from kits supplied by the Gordon-Vantine Company. The barn remains a community landmark.

By 1922, the community needed an expanded school. Conifer Junction School opened in 1923 along Barkley Road on land leased by the Mullens. Generations of Conifer children attended the beloved school, now operated by Conifer Historical Society and Museum and known as the Little White Schoolhouse.

The Schoonhoven family bought property near the junction in 1948 and established Flying J Ranch. John Schoonhoven, a United Airlines pilot, built a small landing strip on his property for his private plane. In 1995, the Schoonhovens sold land to Jefferson County Open Space to create the beautiful Flying J Ranch Park.

Tremendous population growth led the Jefferson County School District to build a spacious new high school in 1996 just southwest of the original junction. Construction of the high school, renovation of the Yellow Barn, the opening of the Little White Schoolhouse as a museum, and the creation of Flying J Ranch Park again made the junction area vitally important to the Conifer community, just as it had been in 1859.

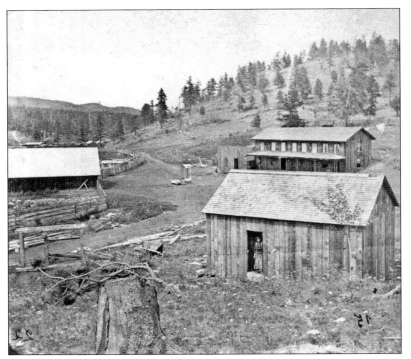

Two important toll roads, the Mount Vernon and Bradford Toll Roads, met in 1860 at the location known as Junction or Bradford Junction. The large building in the background is the original hotel. The Civil War Well can be seen at the crossroads. The building in the foreground may have been the original school. (Courtesy Park County Local History Archives.)

Maj. Robert Bradford (1813–1876) secured a charter and funding to build the Denver, Bradford & Blue River Toll Road in 1859. The roadway was usually called the Bradford Toll Road. It ran from Denver through today's Ken-Caryl Ranch area south along the ridges overlooking Turkey Creek, eventually reaching Fairplay and the gold mining areas in South Park. (Courtesy History Colorado, scan 10039676.)

Bradford built an imposing stone home along his toll road. He expected that it would become the nucleus of a town and grandiosely named it Bradford City. Sadly, nothing much developed at the site except Bradford's own house. After his death, the Perley family bought the property. The young Perley sisters are shown here in front of the house. (Courtesy EMAHS.)

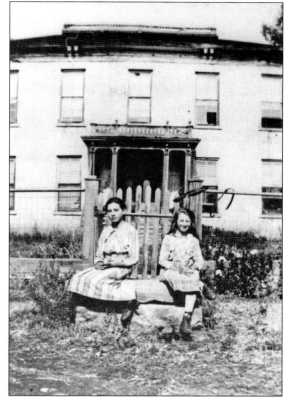

Bradford's home gradually fell into ruins, especially after a disastrous fire in 1967. The home was in disrepair and in danger of collapse when Ken-Caryl Ranch received a grant from the State Historical Fund in 2006 to stabilize it. During the Civil War, recruiting for the Union army reportedly took place at Bradford's house. (Courtesy EMAHS.)

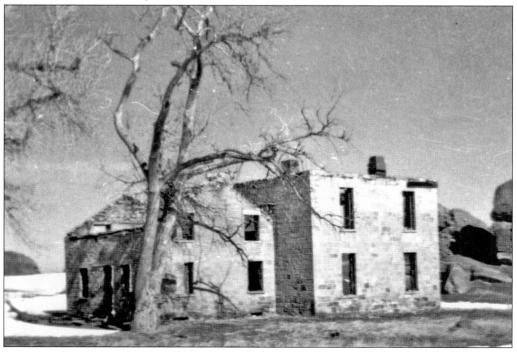

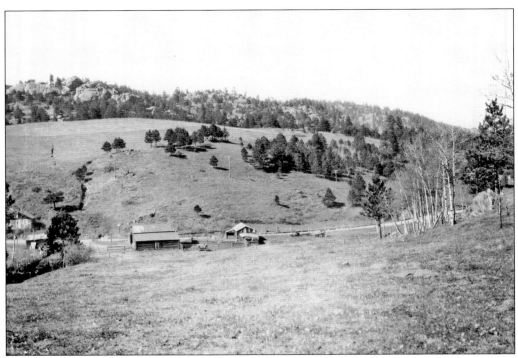

This 1930s view shows the old Bradford Toll Road as it comes over the western edge of the steep Bradford Hill and reaches Turkey Creek. The photograph gives little idea of the rough and hazardous state of the road in the 1860s. (Courtesy History Colorado, scan 10035979.)

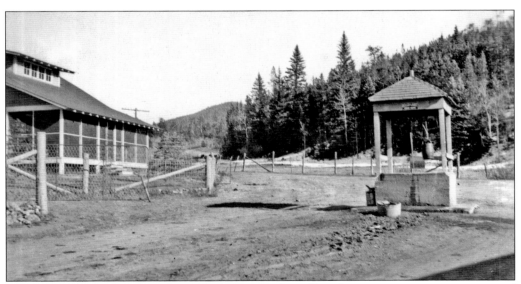

The well at the junction was being dug when a rider galloped up to report important news of the Civil War. It may have been the firing on Fort Sumter, the Battle of Bull Run, or some other significant event. In any case, since then the well, still in its original location, has been known as the Civil War Well. (Courtesy Denver Public Library, Western History Department.)

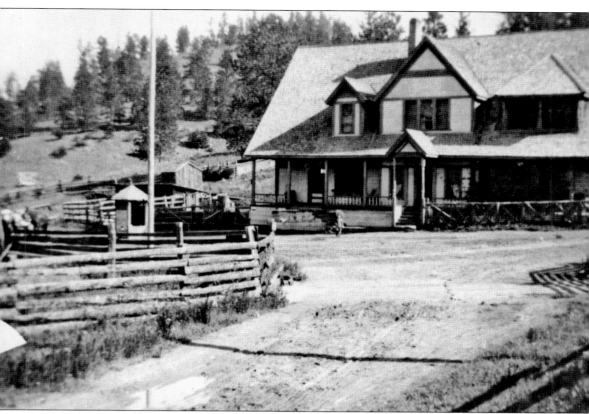

James McNasser owned the junction area by the time the original hotel burned in 1878. By then, much toll road traffic had been replaced by railroad travel, and the replacement hotel McNasser built was more for tourists than travelers along the old roads. (Courtesy EMAHS.)

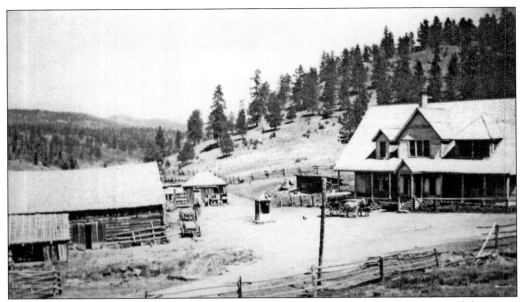

Another 1880s view of the junction hotel shows the crossroads area. The post office was in a separate building south of the hotel. (Courtesy Park County Local History Archives.)

This formal photograph shows Evaline Hamer, who bought the junction ranch and hotel after James McNasser reportedly lost the properties in a card game. She was noted for hosting popular entertainment events at the hotel, including dances and parties at Christmas and the Fourth of July. (Courtesy Denver Public Library, Western History Department.)

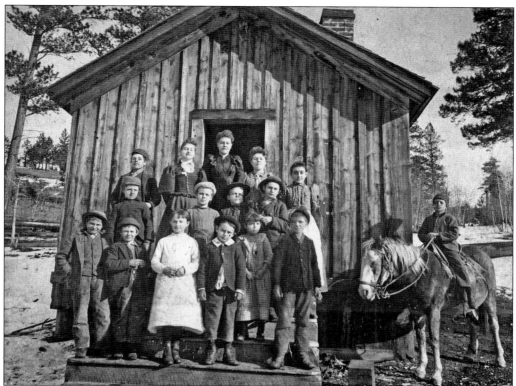

Colorado territorial law allowed a school district to be created if 10 parents of school-age children petitioned for one to be organized. Parents in the Conifer area petitioned for a school district as early as 1860. Eventually, School District No. 9, the Junction District, was created. The Hutchinson School, located about a half mile south of the toll road crossroads, was built in 1885. In this c. 1900 photograph, Emma Shock stands in front of the school with her students. Former student Hazel Bennett Kettle referred to the school as a "shack." (Courtesy History Colorado, scan 10049023.)

This charming photograph shows Myrtle Cook, one of the teachers at the Hutchinson School at the turn of the 20th century. Longtime Conifer teacher Phebe Granzella stated that many female teachers were paid roughly $40 per month at this time or sometimes a flat fee of $400 a year. (Courtesy Denver Public Library, Western History Department.)

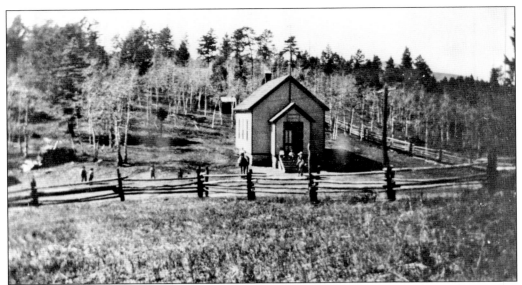

The Junction School, originally a church of the Reorganized Church of Jesus Christ of Latter Day Saints, was built by the Kemp family. It was modified and used as a school reportedly starting in either 1897 or 1911. (Courtesy EMAHS.)

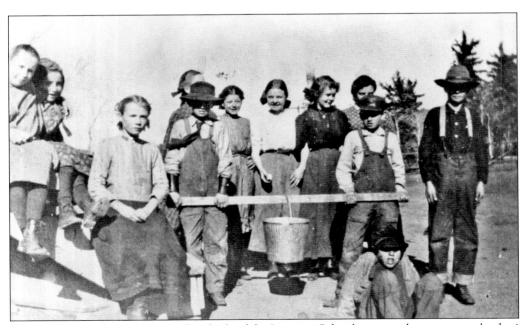

Apparently, it took the entire student body of the Junction School to carry that one water bucket! The school year typically lasted three to four months in the early 1900s. (Courtesy EMAHS.)

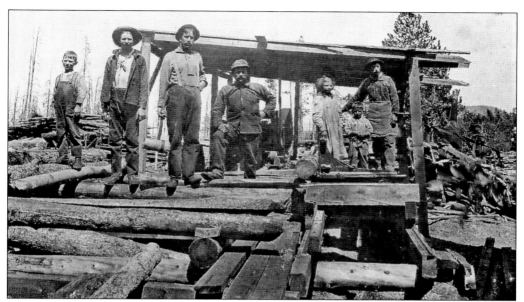

Shadow Mountain Drive leads from Highway 73 along spectacularly beautiful North Turkey Creek. The Welch and Woods families were among the early settlers. This sawmill photograph shows, from left to right, Ransom Woods, son of Henry Woods; two hired hands; Charlie Welch; Ransom's sister Ethel Woods; Ransom's brother Dan Woods; and possibly Dan Norton. Charlie Welch was known as "Charcoal Charlie" because of his charcoal-burning operation supplying fuel. (Courtesy CHSM.)

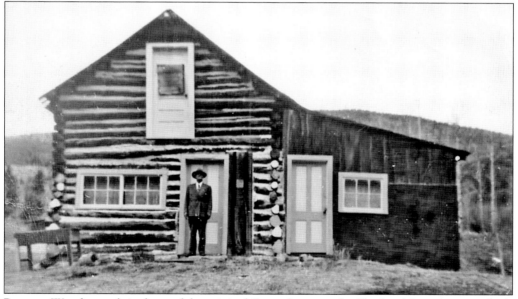

Ransom Woods stands in front of the original Spicer home in the Shadow Mountain area, built around 1893 when the Spicers homesteaded 320 acres of land. The cabin survives and is now owned by the Woods family. The addition on the right, containing a kitchen and bedroom, has been torn down. The nearby Welch family operated Welch's Town Resort, including 14 guest cabins, a grocery store, and a dance hall. (Courtesy CHSM.)

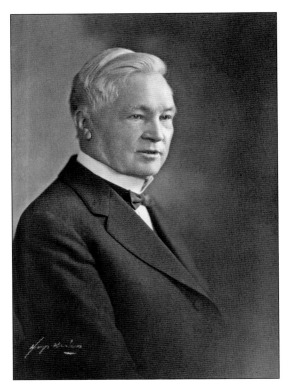

John Kern Mullen was a wealthy flour milling magnate and noted philanthropist in the Denver area. His nephew John J. Mullen bought the junction ranch in 1918 and built the landmark Yellow Barn. The Mullen family owned the junction property until the 1940s. (Courtesy History Colorado, scan 10027936.)

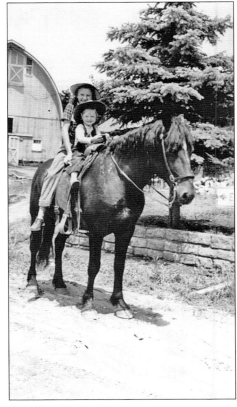

Gerda and little Irene Wilhelm enjoy horseback riding on their family ranch around the 1940s. No activity is recalled with more affection by those who grew up on ranches than riding and the sense of freedom that it brought. (Courtesy CHSM.)

Irene (left) and Gerda Wilhelm, with their cat, pose at the Civil War Well in this late 1940s photograph with the Yellow Barn in the background. The small house surrounding the well was rebuilt by the Wilhelms. (Courtesy CHSM.)

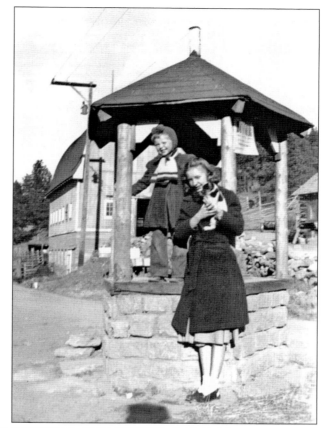

A horse-drawn wagon on the Wilhelm Ranch carries a huge load of hay in the 1950s. Ranchers in the area harvested enormous quantities of hay and alfalfa to feed draft animals and livestock. (Courtesy CHSM.)

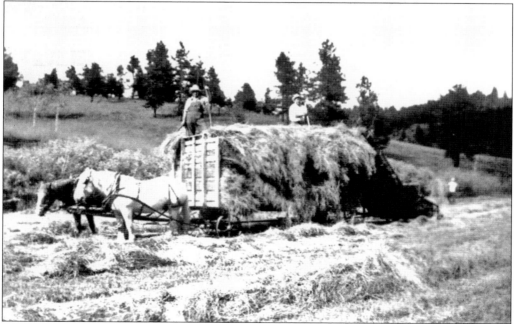

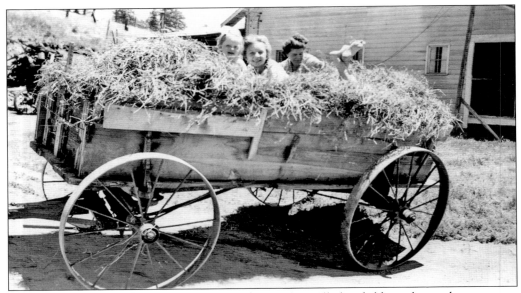

The Wilhelm children play in the straw in an old farm wagon in this 1950s photograph. Simple pleasures like this are fondly remembered by those who grew up before the Internet and cell phones. (Courtesy CHSM.)

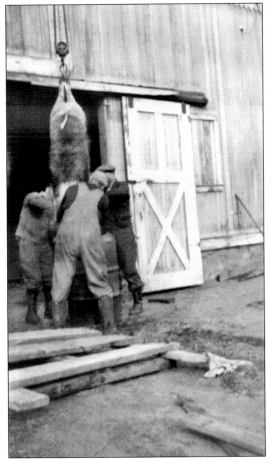

Workers are butchering a hog on the Wilhelm Ranch at the traditional time in the fall. Ham, bacon, and sausage were then prepared and cured to carry the family through the winter. (Courtesy CHSM.)

The faithful ranch dog looks over the property of the Currier family in the 1950s. The Yellow Barn and accompanying buildings can be seen at the junction in the distance. (Courtesy CHSM.)

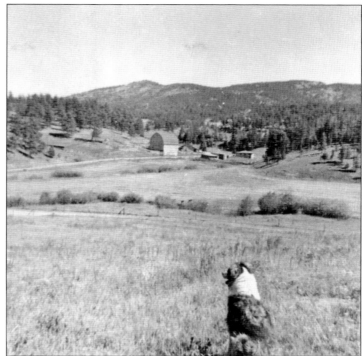

The Currier ranch buildings and the Yellow Barn at the junction are shown in the 1950s. The Curriers owned the junction area ranch from 1955 to 1989. (Courtesy CHSM.)

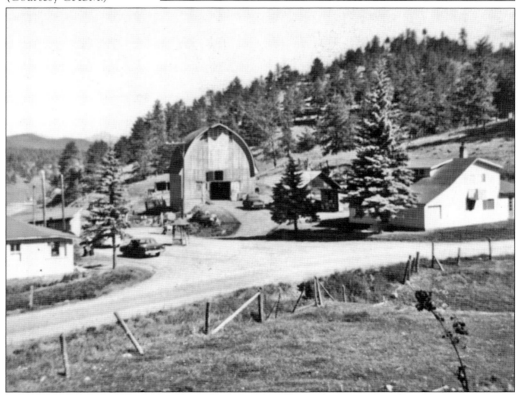

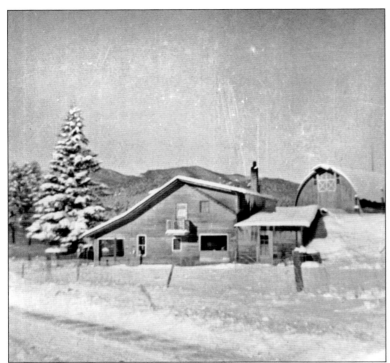

The Currier ranch house is buried deep in snow in a late 1950s winter. Winters can turn brutally cold in Conifer, and blizzards bring swirling clouds of snow that can pile up to three and four feet at times. (Courtesy CHSM.)

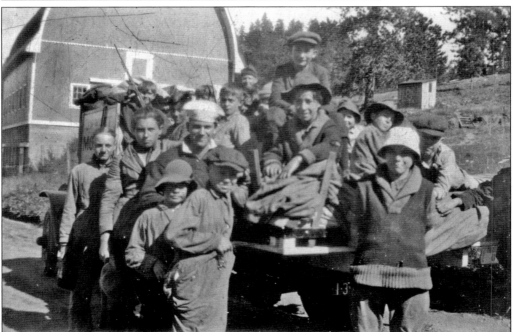

Boys from the Byers Peak Ranch for Boys, on an excursion to Conifer, pose with a sailor in front of the Yellow Barn in this photograph, probably taken in the 1940s. The Byers Peak Ranch for Boys was established in 1932 by Jessie Arnold and operated until the early 1940s. (Courtesy Denver Public Library, Western History Department.)

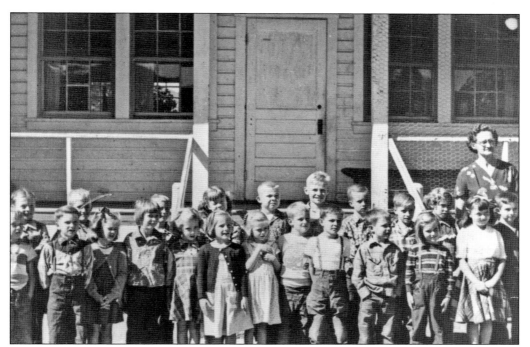

Beloved teacher Phebe Granzella proudly stands with her first-, second-, and third-grade students in front of Conifer Junction School in 1953. This was the main school building in the area from 1923 until 1955. (Courtesy EMAHS.)

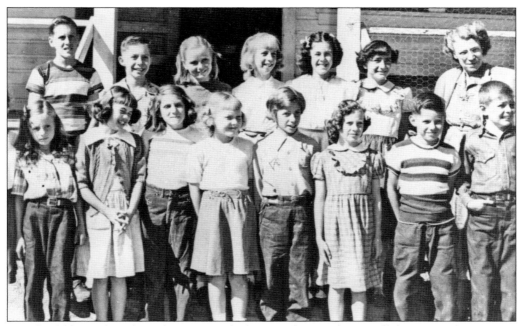

Fourth-, fifth-, and sixth-graders pose with their teacher, Pauline Griffith, at Conifer Junction School in 1953. Griffith was part of the pioneer Huebner family and was one of the teachers involved with the local Pleasant Park 4-H Club. (Courtesy EMAHS.)

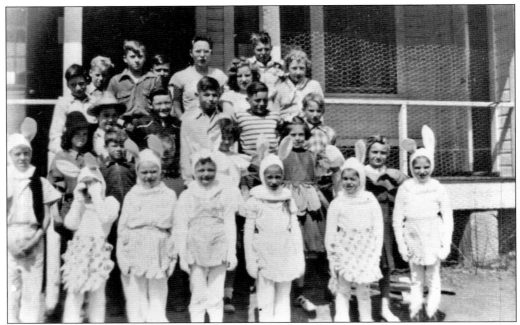

It's Eastertime at the Conifer Junction School! The school was often the site of holiday community celebrations, and the students may be preparing for an Easter pageant in this 1950s photograph. (Courtesy EMAHS.)

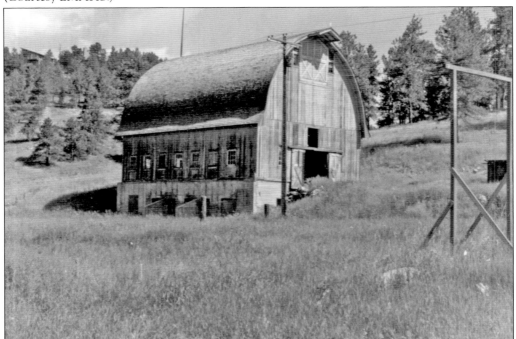

By 1980, the Yellow Barn had endured years of neglect, and community concern about its future was intense. Several plans to save the barn were proposed, but none of them progressed due to lack of funding. (Courtesy EMAHS.)

John and Marguerite Schoonhoven purchased property along Highway 73 in 1948, dubbing it Flying J Ranch. John was a pilot for United Airlines, and built a private airstrip on the ranch for his Stearman biplane, later replaced by a Cessna 180. The Schoonhoven ranch buildings can be seen next to the park. (Photograph by Tim Sandsmark.)

In 1995, the Schoonhovens sold 418 acres of their ranch to Jefferson County Open Space, creating the beautiful Flying J Ranch Park. The park offers three miles of trails amid extensive pine and fir forests and ponds. Vestiges of the original homestead structures survive at Flying J Ranch Park. They are maintained by the Jefferson County Open Space staff. (Photograph by Tim Sandsmark.)

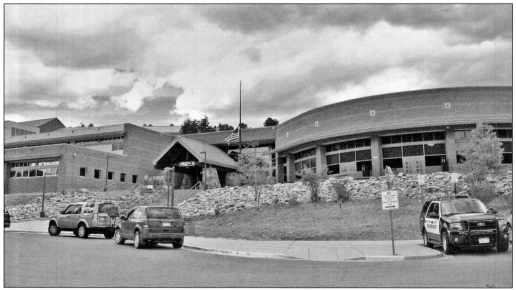

When the new Conifer High School opened in 1996, it offered high school–level education in Conifer for the first time—students no longer had to be bussed to Evergreen. The massive main building received three design awards from education facilities planners and school administrators. (Photograph by John Steinle.)

Conifer High School sophomores Natalie Vandenkamp, left, and Nicole Myers survey an area burned over by the Buffalo Creek Fire in 1996. Their outdoor biology class was documenting vegetation recovery as part of their high school studies. (Courtesy Evergreen Newspapers.)

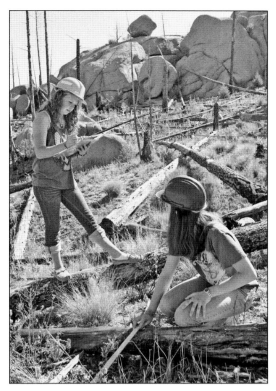

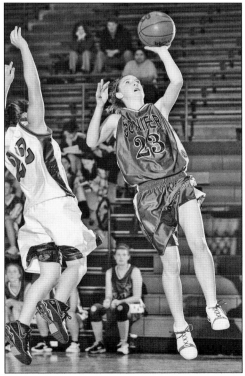

Sports teams at Conifer High School run the gamut of football, basketball, baseball, soccer, lacrosse, softball, wrestling, track, swimming, golf, and others. Here, Alison Gorrell makes a layup while playing Alameda in 2009. She scored 34 points in the game, and Conifer won. (Courtesy Evergreen Newspapers.)

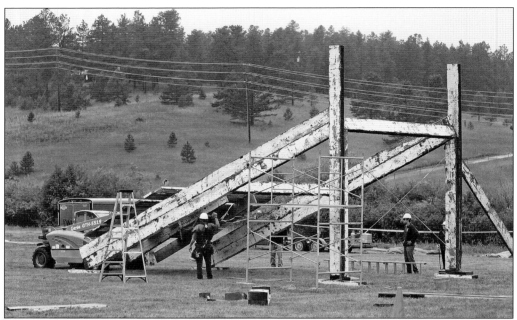

The Journey Church in Conifer drew national attention when it broke a Guinness world record by constructing the world's largest lawn chair in 2013 on the church's 45-acre property along Highway 73 near the old junction area. The church was eventually embroiled in controversy over unpaid debts and other issues, and left Conifer in 2014. (Courtesy Evergreen Newspapers.)

In 2016, Craig Marks bought the old junction area, including the Yellow Barn and its surrounding buildings. He has ambitious plans to completely renovate the old barn and hold square dances there, just as in the old days of the 1930s and 1940s. (Photograph by Tim Sandsmark.)

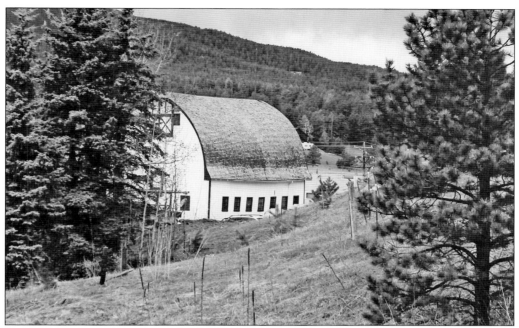

Today's Yellow Barn complex includes the Magpie Mercantile, located inside the barn, the Well bar and restaurant, and Creative Minds Early Learning Center. The Civil War Well is still at its original location, although the roadway has changed its route. (Photograph by Alex Witt.)

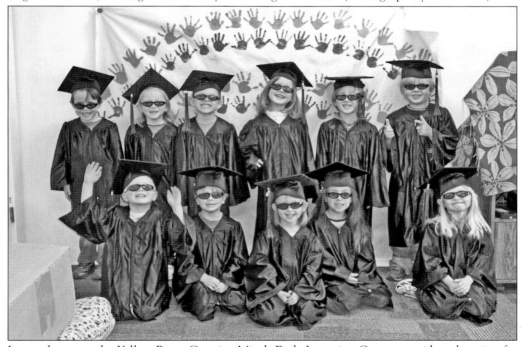

Located next to the Yellow Barn, Creative Minds Early Learning Center provides education for children from preschool through kindergarten. In this photograph, the students in the preschool class of 2011 celebrate their graduation. (Courtesy Evergreen Newspapers.)

Since acquiring the old Conifer Junction School in 2009, CHSM volunteers have accomplished wonders in renovating and revitalizing the old school buildings. The society sponsors a monthly series of popular programs on local and regional history. (Courtesy Suzi Morris.)

Three

ASPEN PARK

Much of the land just east of today's Aspen Park was occupied by the Lubin family ranch in the late 1800s. The Lubins were apparently a troubled family; neighbors whispered tales of abuse, murder, and suicide. John Lubin was brought into court in Golden in 1881 after his wife's sudden death, but no charges were filed against him. After the Lubins, the Blakeslee family purchased the ranch and its perpetually flowing Indian Spring.

In 1955, the Conifer Valley Development Company bought a level area of land along Highway 285 formerly owned by the Legaults, Browns, and others. The development was dubbed Aspen Park. Aspen Park is often seen as a separate community from Conifer, even though both are unincorporated and Aspen Park is part of the Conifer zip code area.

Today, Aspen Park includes a variety of businesses, schools, and churches. Businesses include the Aspen Park Village complex, anchored by a King Soopers store. The former Lubin/Blakeslee cabin and barn were moved to the Norm Meyer property, a difficult project showcased on the History Channel's *Mega Movers* program.

Both West Jefferson Elementary School and West Jefferson Middle School are within Aspen Park, serving an estimated 975 students. West Jefferson Elementary opened in 1955, with several subsequent enlargements and a total removal to build a new school farther back on the hill. The school serves preschool through fifth grade, and its mascot is a bobcat. West Jefferson Middle School began as a junior high in 1974 before becoming a middle school in 1996 serving grades six through eight. The colt is the school mascot.

Worship services are held at four churches within Aspen Park: Conifer Community Church, St. Laurence Episcopal Church, Our Lady of the Pines Catholic Church, and Aspen Park Seventh-Day Adventist Church.

Aspen Park has been home to live theater since Stage Door Theater debuted in 1990. In 2003, the theater added a student company to its existing adult troupe. To date, it has presented more than 120 productions ranging from adult dramas to musicals.

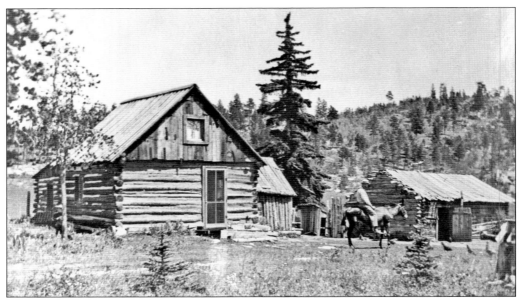

The John Lubin family developed their ranch on 160 acres of the former Duncan McIntyre property near the Bradford Toll Road route. Their strongly-built log home survives, having been moved to the nearby Norm Meyer property in 2007 when construction of the King Soopers shopping area threatened to destroy the old dwelling. (Courtesy EMAHS.)

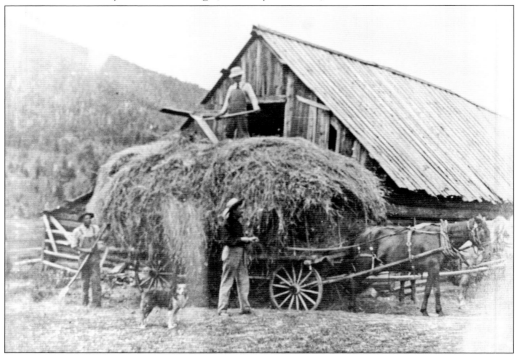

Workers load hay into the Lubin barn in this c. 1907 photograph. The barn also survives, having been moved to the Meyer property at the same time as the cabin in a very complicated maneuver. (Courtesy EMAHS.)

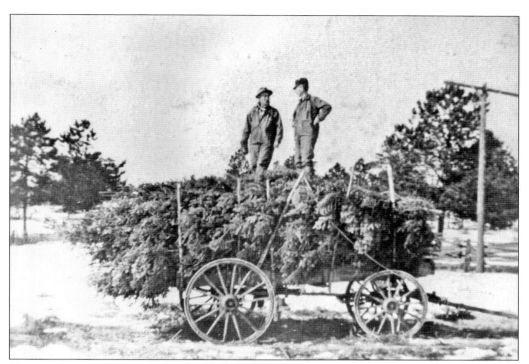

Two workers stand atop a wagonload of Christmas trees being harvested on the Lubin ranch around 1907. Mountain ranches tended to be much more diversified than flatland ranches that concentrated on raising livestock. Conifer-area ranchers also harvested root crops and hay, cut timber, operated sawmills, and marketed Christmas trees. (Courtesy EMAHS.)

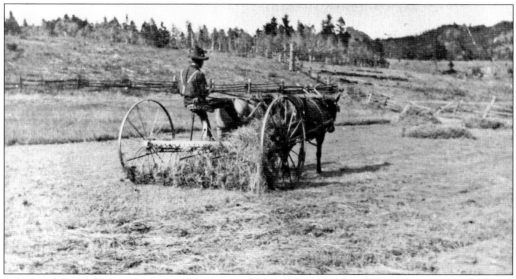

A horse-drawn rake gathers straw for baling on the Lubin ranch in 1907. Straw was mixed with fodder for animals and had numerous other uses around the ranch, including bedding. (Courtesy EMAHS.)

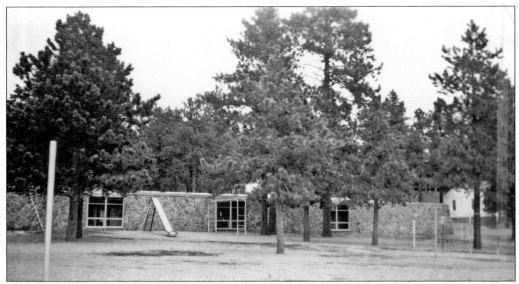

The original West Jefferson Elementary School was built in 1955, offering area students a relatively modern, well-equipped school building to replace the numerous tiny one-room schools scattered around Conifer. (Courtesy CHSM.)

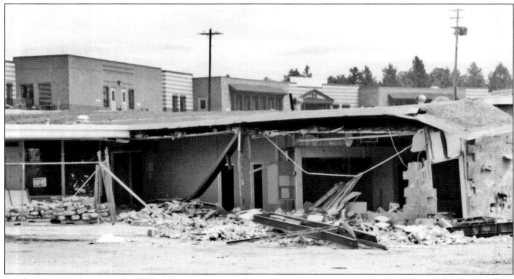

In the 1960s, the West Jefferson Elementary School building was enlarged. It was replaced in 2000 by the present structure. This photograph shows the original school being demolished, with the new elementary school behind it. (Courtesy CHSM.)

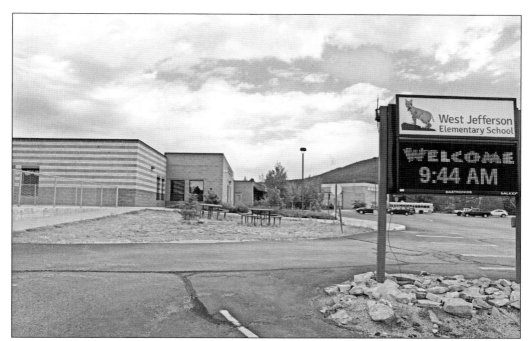

The new West Jefferson Elementary School building was completed in 2000, serving about 400 students. The spacious building is quite a contrast to the cramped one-room schools of the past. (Photograph by Tim Sandsmark.)

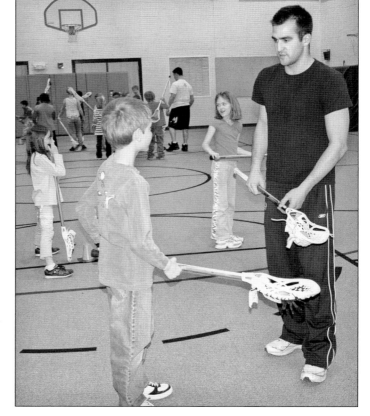

In 2009, Jamie Shewchuck, professional lacrosse player for the Colorado Mammoth, shows West Jefferson Elementary School third-grader David Jacobsen how to hold a lacrosse stick. This training was part of the Mammoth Sticks 4 Schools program. (Courtesy Evergreen Newspapers.)

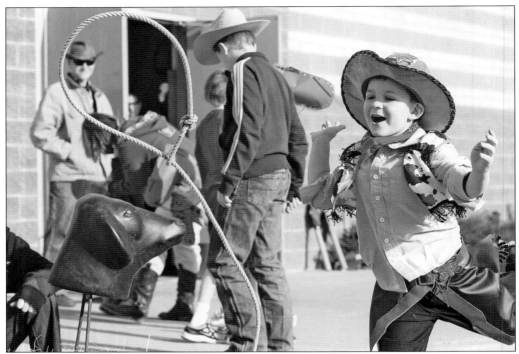

Dylan Panarello practices roping a calf during the West Jefferson Elementary School Rodeo in 2009. Kindergarten classes at the school include math, social studies, and science. (Courtesy Evergreen Newspapers.)

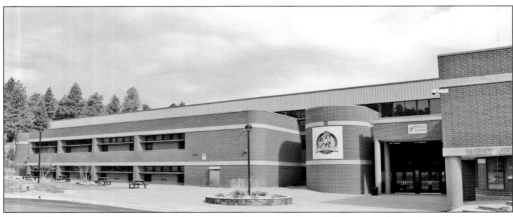

West Jefferson Junior High School opened in 1974, serving grades seven through nine. It was part of a massive building program by Jefferson County School District that saw 15 schools constructed in a two-year period to accommodate suburban population growth. In 1996, the school transitioned to a middle school serving grades six through eight. (Photograph by Tim Sandsmark.)

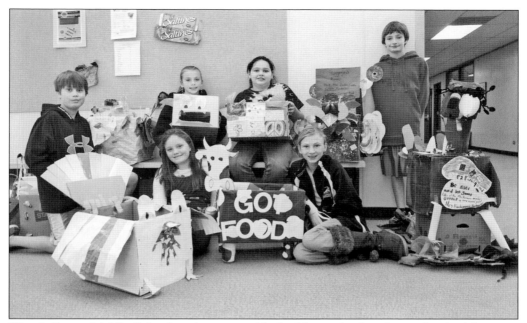

West Jefferson Middle School students assemble food boxes for distribution by the Mountain Resource Center in 2011. Students are encouraged to participate in charitable activities in the community. (Courtesy Evergreen Newspapers.)

West Jefferson Middle School students, led by teacher Frank Reetz, assist Denver Water Board staff in moving and reinstalling the Westall Monument along the South Platte River in 2013. The monument honors Billy Westall, a railroad engineer who sacrificed himself to save a trainload of passengers in 1898. (Courtesy Evergreen Newspapers.)

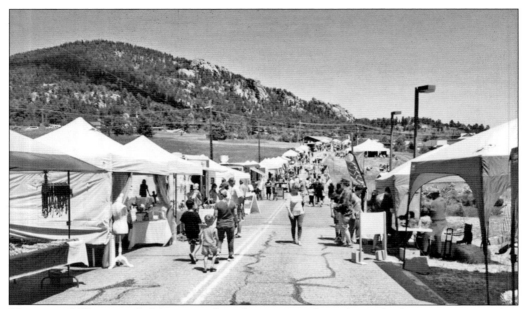

The annual Elevation Celebration takes place in Conifer in late July, featuring a street fair, music with about 20 different bands, and a 5K charity trail run. The two-day event is one of the largest gatherings in Conifer and is entirely organized and run by community volunteers from the chamber of commerce, Kiwanis, Rotary, and other groups. The event is sponsored by local businesses. (Courtesy Conifer Area Chamber of Commerce.)

Most local schools participate in the Christmas parade. The event, which began in 1982, provides a focal point for the community to gather and celebrate the season. (Courtesy Richard and Bonnie Scudder.)

Every December, the Conifer community joins in a joyous celebration of the season and holds a Christmas parade through Aspen Park. Many local organizations create handmade floats to participate. (Courtesy Richard and Bonnie Scudder.)

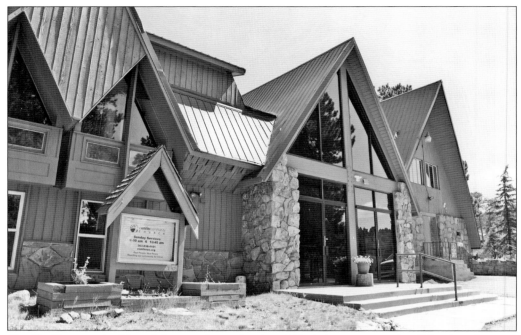

Conifer Community Church is a nondenominational Christian congregation. The church serves a large congregation, and its members often participate in charitable activities such as the free firewood lot adjacent to the church. (Photograph by Tim Sandsmark.)

Women of the Conifer Community Church participate in a Habitat for Humanity building project in 2010. Construction was intended to provide affordable housing for under-resourced people. (Courtesy Conifer Community Church.)

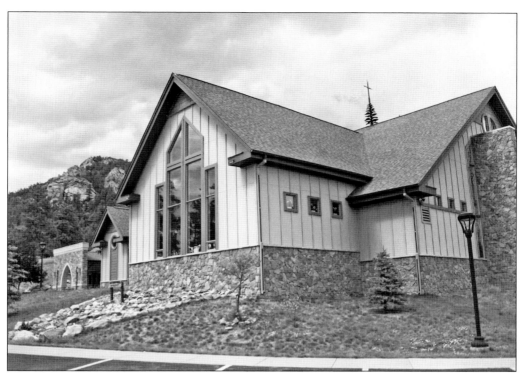

In the late 1970s, Catholics living in the Conifer area began to request the creation of a Catholic parish. By the early 1980s, the result was construction of a small parish building, and 10 years later, Our Lady of the Pines Parish was formally established. The present church building was completed in 2006. (Photograph by John Steinle.)

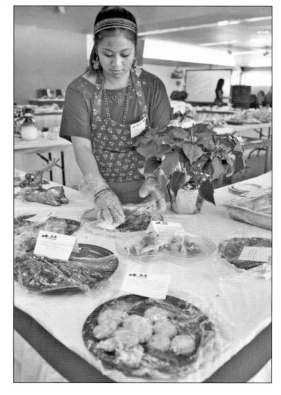

Emily White arranges cookies for the annual Our Lady of the Pines cookie sale. In 2010, the church sold more than 700 pounds of cookies and candy. The proceeds benefit the church's charitable activities. (Courtesy Evergreen Newspapers.)

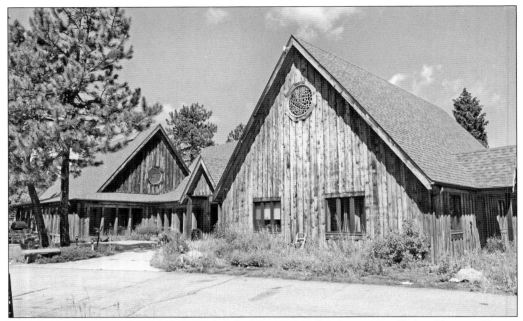

Beginning in 1977 with a service in a local restaurant at the invitation of Mary Frances Young, the Episcopalian mission in Conifer grew as it met in various restaurants and other venues. In 1983, land for a church was purchased, and in 1987, the new church was dedicated as St. Laurence Episcopal Church. (Photograph by Tim Sandsmark.)

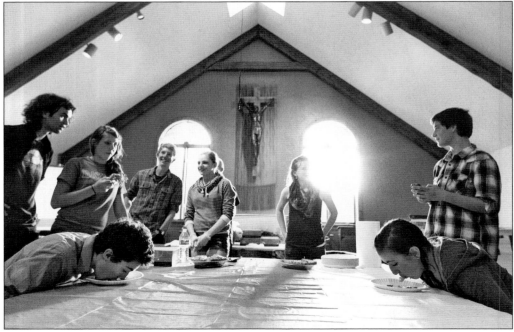

Wyatt Guernsey and Erin Blair compete in a 2013 pie-eating contest at St. Laurence Episcopal Church sponsored by Conifer Rotary. The event was a benefit to assist the Intermountain Humane Society. (Courtesy Evergreen Newspapers.)

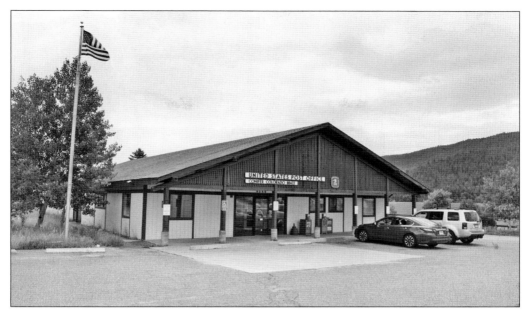

When the Conifer Post Office building was completed in the 1990s, it changed the traditional story of postal delivery in the Conifer area. Previously, post offices had been in local ranches and general stores in many different locations. Now, Conifer residents could visit a central location to pick up or drop off mail and packages. (Photograph by Tim Sandsmark.)

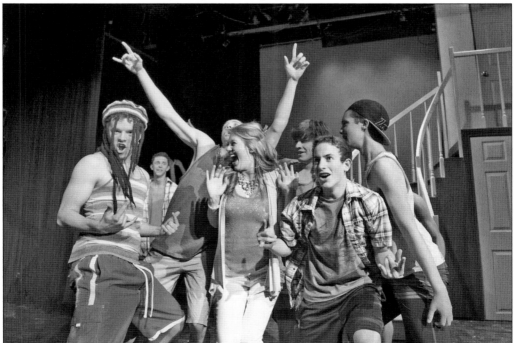

The hilarious comedy *Legally Blonde* was presented by Stage Door Theater in 2013. Thirty-five students from area schools participated, and the production featured a seven-piece orchestra and pink costumes provided by the Arvada Center. (Courtesy Evergreen Newspapers.)

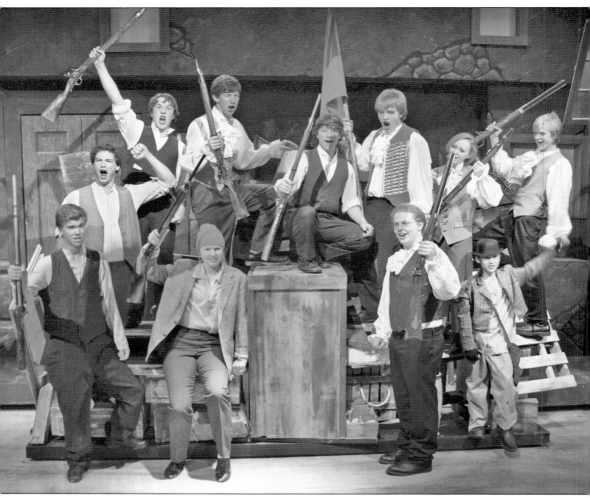

In 2009, Stage Door Theater offered its production of the spectacular musical *Les Miserables*, based on the novel by Victor Hugo. The production gave an opportunity for the theater's high school–age students to man the barricades and show off their talents. (Courtesy Evergreen Newspapers.)

Four

PLEASANT PARK

Pleasant Park Road begins at Highway 285, where it originally intersected with the old Bradford Toll Road route, and continues east to Critchell. At Critchell, it becomes the steep High Grade Road, then Deer Creek Road before its junction with Deer Creek Canyon Road where the village of Phillipsburg once stood.

The Pleasant Park community really began to develop in the mid-1870s, when the Legaults, Kuehsters, Huebners, Corbins, and others homesteaded ranches in the area. The 1877 Hayden Survey map calls the area Hay Claim Park.

As early as the 1870s, Pleasant Park residents built a small log school with their own hands. When the growth in population made the old school obsolete, Joseph Huebner, assisted by the Kuehsters and other families, built Pleasant Park School in 1894. The building is now owned and maintained by the Pleasant Park Grange.

Pleasant Park residents formed tight-knit relationships, shown by festive Fourth of July celebrations at the Huebner ranch, Christmas celebrations and student recitations at the school, and memberships in the Pleasant Park Grange.

The community spirit in Pleasant Park was shown in 1919 when residents volunteered to build half of the High Grade Road themselves, replacing the former steep, rutted pathway down to Deer Creek. Jefferson County agreed to build the other half.

The second gold rush of the 1890s led to the development of a new community known as Critchell in Pleasant Park. Founded in 1897 by English immigrant C.R. Critchell and his associates, the town was surveyed with 600 lots, and the founders hoped it would become a second Cripple Creek due to the nearby gold, silver, bismuth, and copper mines. The town even boasted of its own newspaper, the *Rocky Mountain Reveille*. Unfortunately, by the early 1900s the veins of ore were exhausted, and the town faded away.

Today, Legault Mountain, Huebner Peak, and Kuehster Road commemorate these Pleasant Park pioneers.

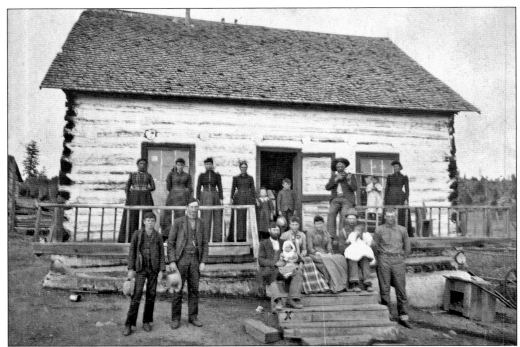

Joseph Legault emigrated from Canada in 1869, then settled in the Pleasant Park area, known as Hay Claim Park at the time. He is shown in this c. 1880 family photograph at the Legault log home aiming a rifle on the porch. The Legault ranch was originally a 160-acre homestead claim. Joseph's two adult sons from his first marriage, Alphonse and Joseph Jr., also owned ranches in the area. (Courtesy History Colorado, scan 10049022.)

The Rogers family settled in the present-day Oehlmann Park area near Pleasant Park Road in 1894. Frederick and Helen Rogers had 10 children. Among them, only Margaret stayed in the Conifer area, spending the rest of her life there after marrying James Granzella. (Courtesy EMAHS.)

Joseph Huebner's family were among the most influential ranchers in the early Pleasant Park area. He spearheaded construction of the Pleasant Park School, and his wife, Clara, was master of the local Pleasant Park Grange. (Courtesy CHSM.)

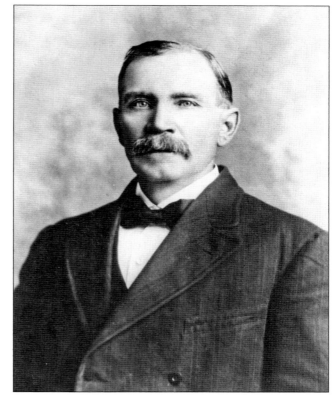

Pleasant Park School was built by local ranch families in 1894 to replace an earlier log building. It closed as a full-service school in 1946 but was used as an overflow school as late as 1955 until the new West Jefferson Elementary School in Conifer was completed. (Courtesy EMAHS.)

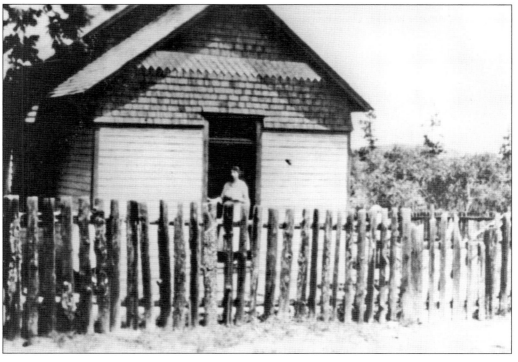

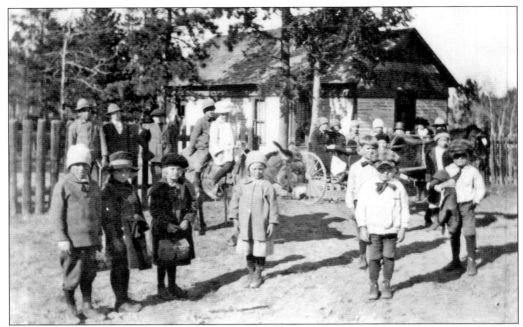

In the early days of the Pleasant Park School, students and teachers rode either horses or burros or arrived in family buggies. It is said that when she was a student, future teacher Pauline Griffith rode her burro to school from Critchell, four miles away. (Courtesy CHSM.)

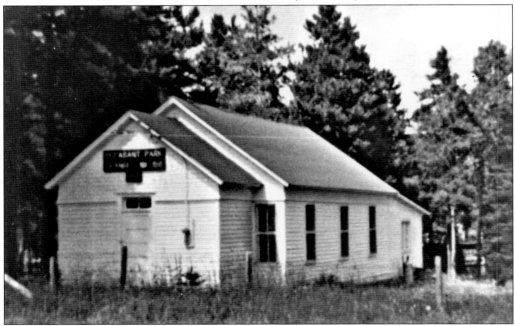

Like other one-room schools, Pleasant Park School became a center for community gatherings and was used as a Grange hall. It is currently owned and maintained by the Pleasant Park Grange. The Grange (officially known as the Patrons of Husbandry) is a national organization founded in the 1860s helping farmers to unite for political and economic influence. (Courtesy CHSM.)

Frederick and Lina Caroline Kuehster are pictured with their children (from left to right) Fritz, Bertha, Carl, and Otto around 1882. Frederick and Lina were both German immigrants who settled in Pleasant Park (then Hay Claim Park) in the late 1870s. (Courtesy CHSM.)

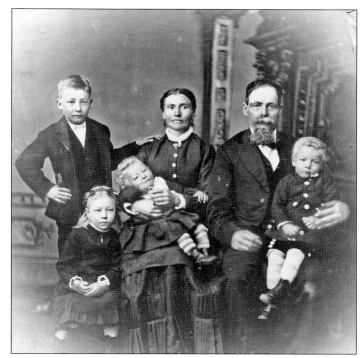

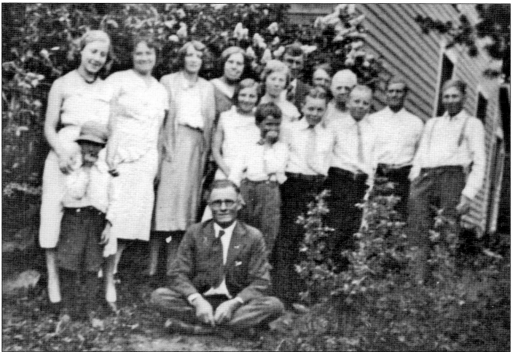

The numerous Kuehster family members gather in 1932. Frederick and Lina Kuehster had four children who spread throughout the Pleasant Park area with their own ranches. The Kuehster grandchildren and great-grandchildren numbered in the dozens. (Courtesy CHSM.)

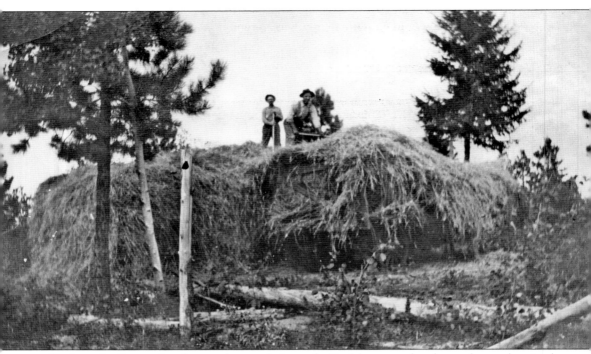

Kuehster family members harvest hay on their ranch. Draft horses and mules used as work animals consumed huge quantities of hay, which was grown and sold by the ranchers in the former Hay Claim Park. (Courtesy CHSM.)

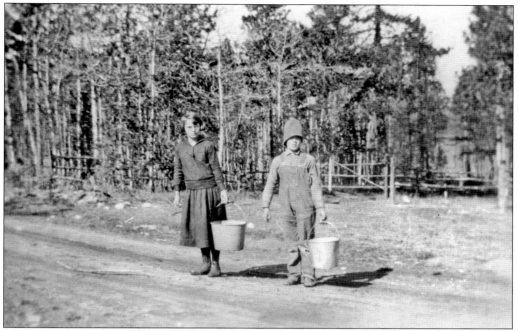

Since many schools did not have wells or other access to water, students often were required to bring their own water from a nearby spring for the school day. Here, two children are lugging their water buckets to the Pleasant Park School. (Courtesy CHSM.)

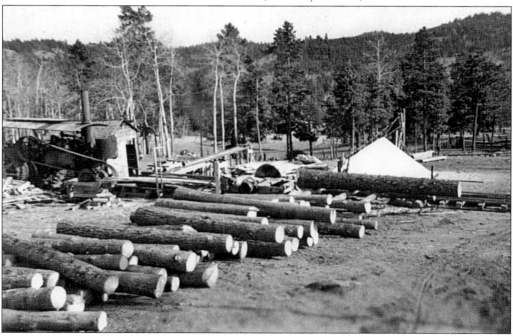

The massive size of the logs at the Kuehster sawmill illustrates the abundant quantities of first-growth timber available for harvesting in Pleasant Park. Such timber has become scarce, and the last sawmill in the Conifer-Evergreen area closed in 2003. (Courtesy CHSM.)

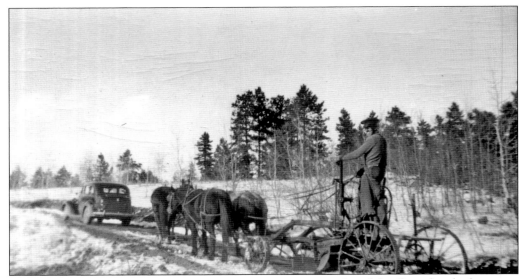

Local families often had to contribute their own labor or work for Jefferson County to maintain the roads where they lived. Here, Carl Kuehster operates a horse-drawn road grader as late as 1947. (Courtesy CHSM.)

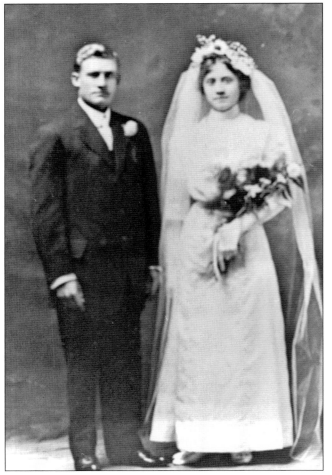

This 1912 wedding picture shows Carl L. Kuehster and Clara Huebner, both members of longtime Pleasant Park ranching families. They enthusiastically supported their community with leadership in the Grange and involvement in building the High Grade Road in 1919. (Courtesy EMAHS.)

Carl and Gertrude Kuehster built their Pleasant Park home in 1912. The Kuehsters raised cattle and grew vegetables. They cut the logs to build their home, then hauled them to a local sawmill to be shaped to length. Later they established their own sawmill on the ranch. (Courtesy EMAHS.)

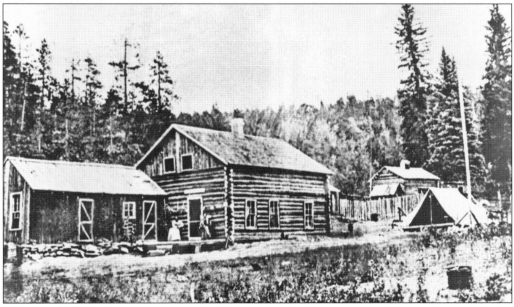

C.R. Critchell's log home was situated in his temporarily thriving town. During the second gold rush of the 1890s, Critchell established a small community on his land along Pleasant Park Road, hoping to profit through land speculation. Several mines operated in the vicinity, producing gold and other valuable minerals. Critchell was betting on an increase in land values as the mines became more productive. (Courtesy EMAHS.)

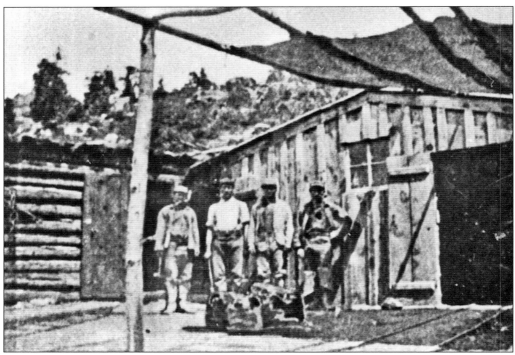

The Anna L. Mine at Critchell was owned by future Colorado governor Elias Ammons. He became notorious for his involvement in the Ludlow Massacre of striking miners in 1914. Although gold ore from the Anna L. was said to be extremely valuable, the veins of ore played out within a few years. (Courtesy EMAHS.)

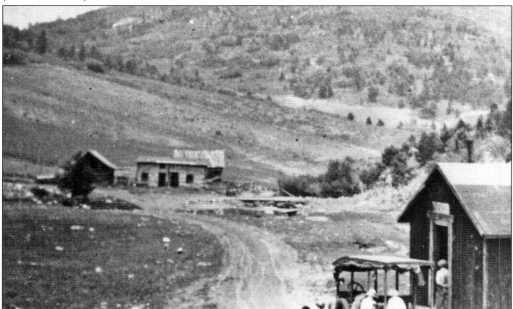

This murky photograph shows the Critchell Post Office in the foreground to the right. In the background can be seen the very rough and primitive stagecoach stop. (Courtesy EMAHS.)

Alfred Packer was known as the "Colorado Cannibal." He lived at Critchell and Phillipsburg after his release from prison in 1901 until his death in 1907. Packer survived by eating the bodies of his five companions in 1874 while snowbound in the southwestern Colorado mountains. Whether he murdered the others or ate them after they were killed by another crazed member of the group is still being debated. (Courtesy History Colorado, scan 10026096.)

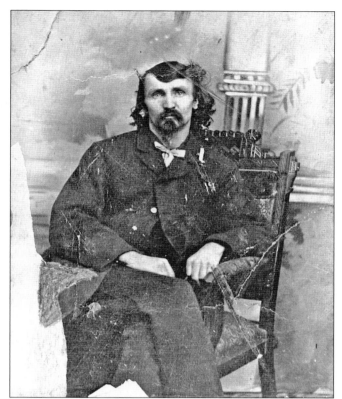

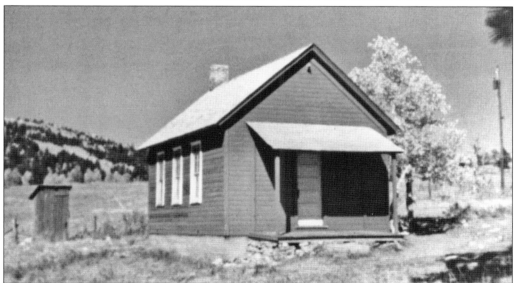

The Lamb, Kuehster, and Huebner families and others built a small log school in 1886 in the Lamb community on Kuehster Road. The original building burned in 1919, and a new school was built by George Hahn. However, the school closed in 1942 when attendance declined. In 1955, it was purchased by the Sampson Community Club and used for neighborhood gatherings. Tragically, Lamb School was destroyed by the North Fork Fire in 2012. (Courtesy EMAHS.)

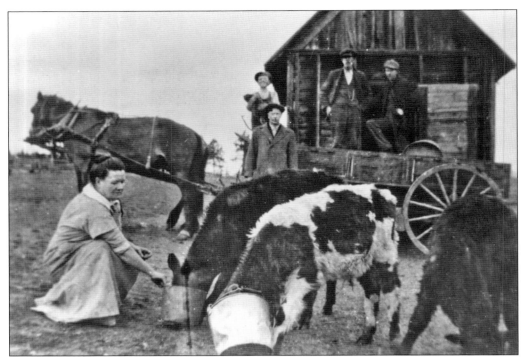

The lucky calves at the Gray Ranch are being hand-fed by Elsie Gray in this photograph from 1916 or 1917. The Gray family moved to Pleasant Park from Oklahoma about 1913. Thomas Gray had participated on horseback in the famous Cherokee Strip Land Rush of 1893. He and his wife, Elsie, had six children in Oklahoma before moving to Kansas and then Colorado. (Courtesy EMAHS.)

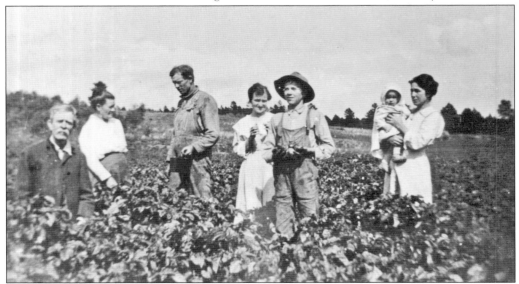

The Gray family grew annual harvests of 50 to 60 tons of potatoes on their ranch. In this 1918 photograph, from left to right, Tom and Elsie Gray, their son Sharon "Buzz" Gray, his wife Eva, their son Harold, and Eva's mother Zepha Florence Johnson holding Eva's baby Virginia, all work at harvesting. (Courtesy EMAHS.)

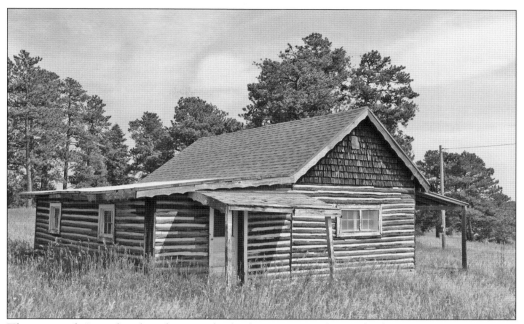

The original Gray family cabin was built about 1919 and was the home of Thomas Gray's son Sharon "Buzz" Gray. Buzz, his wife, Eva, and their eight children lived in this tiny house. (Photograph by Tim Sandsmark.)

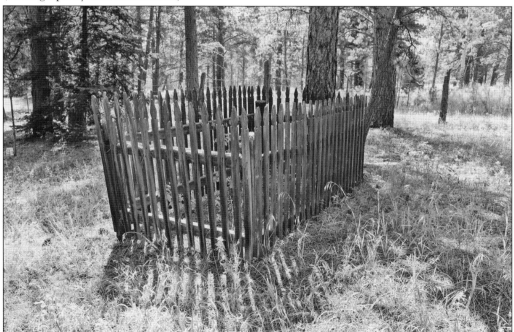

Fourteen-year-old Jesse Brooks died in 1892 and lies in the quiet, secluded Pleasant Park Cemetery. The cemetery is governed and maintained through a volunteer cemetery association, like most small cemeteries in the Conifer area. Many pioneer families lie buried here, including the Legaults, Grays, Corbins, Crockers, and others. (Photograph by Tim Sandsmark.)

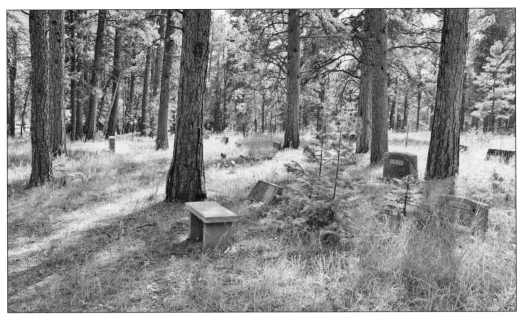

Unlike urban cemeteries, there are no manicured lawns or pretentious monuments in the Pleasant Park Cemetery. The mission statement, posted at the entrance, reads, "Providing a peaceful and natural final resting place that preserves the pioneer spirit and protects the historical integrity of Pleasant Park Cemetery." (Photograph by Tim Sandsmark.)

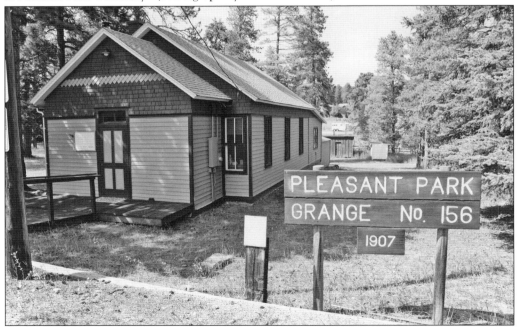

Pleasant Park Grange still owns and maintains the school building erected in 1894 and meets there regularly. In 2003, it established a shady rest stop for cyclists along the popular Pleasant Park Road route next to the Grange building, providing picnic tables and stocking it with water and cookies. (Photo by Tim Sandsmark)

Five

TURKEY CREEK

People have been using the route of Turkey Creek as a pathway to and from the mountains since prehistoric times. The headwaters of South Turkey Creek flow from the slopes of Legault Mountain, while North Turkey Creek originates west of Shadow Mountain Road. The two branches of the creek meet at a location known as the Twin Forks, and then the main branch flows south into Bear Creek Lake.

The Turkey Creek corridor provided an ideal route for the Ute people to follow from their winter refuges in the mountains to spring and summer buffalo hunts on the plains. The Ute Trail ran along the creek and was well known to the early trappers and settlers.

It was natural for Maj. Robert Bradford to follow this time-honored trail when he laid out the route of the Bradford Toll Road in 1859. The road ran from Denver to Bradford's home and then up and along steep hills before meeting the Mount Vernon Toll Road at Bradford Junction and continuing to the gold mining region of South Park.

Bradford's hope of founding a great metropolis faded, partly because a new toll road was built by John Parmalee starting in 1866 and hewing closer to the creek. This more level road was known as the Turkey Creek Road, and it became more popular for travelers than the Bradford Toll Road.

With ranchers and farmers claiming land along Turkey Creek, small communities developed along its banks. Medlen, Brownsville, and Herndon were all well-known villages along the Turkey Creek Road. Medlen survives as a local neighborhood, and its old schoolhouse remains intact.

One of the area's most enduring tourist attractions, Tiny Town, began in 1915 when George Turner, owner of a Denver moving company, constructed miniature buildings to entertain his daughter. By 1921, he expanded the miniature village and opened it to the public as Turnerville, adding a full-size pueblo-style dance hall. Though the dance hall burned in 1935, Turner expanded the village with a rideable miniature railroad, and the name was changed to Tiny Town in 1939.

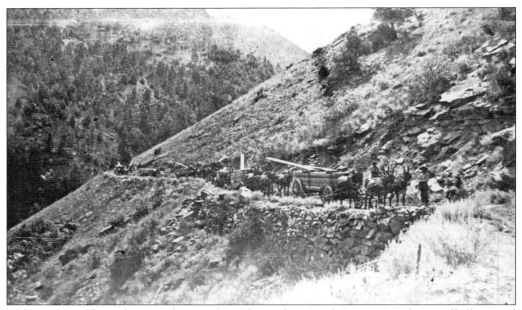

The rough and hazardous conditions along the Turkey Creek Wagon Road are well illustrated in this c. 1910 photograph. The lumber wagons are trying to negotiate an especially dangerous section of the road with a steep drop-off and no guard rail. (Courtesy EMAHS.)

Workers are constructing or repairing a section of the Turkey Creek Wagon Road in this c. 1910 photograph. The road was considered less steep and arduous than the Bradford Toll Road, which led up and over Bradford Hill. Joe Biggar of Medlen Town is one of the workers. (Courtesy EMAHS.)

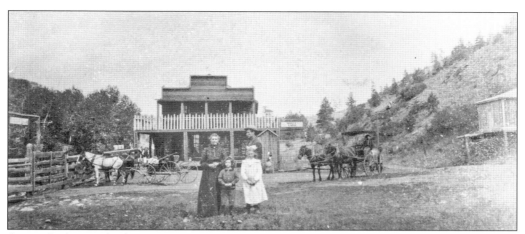

Spruce Lodge was built along South Turkey Creek near the present location of Tiny Town. A.W. and Agnes Ralph built the lodge in 1902 to accommodate travelers along the Turkey Creek Wagon Road. It quickly became a focus of neighborhood gatherings on holidays and all kinds of special occasions. The lodge was dismantled in 1976, and the pieces may still be stored at a local historical society. (Courtesy EMAHS.)

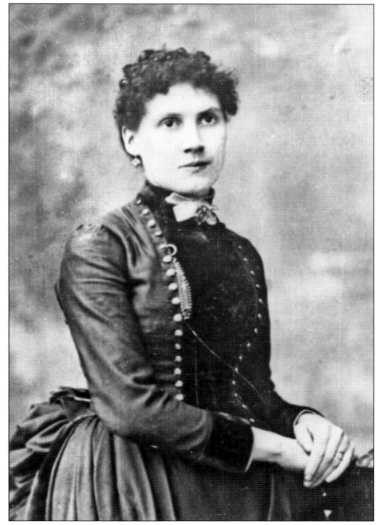

Agnes Ralph looks calm in this c. 1890 portrait, but on Fourth of July celebrations, she would cook for dozens of people at Spruce Lodge. She was famous for her lemon-filled cake and delicious fried potatoes. She and her family worked incredibly hard to make Spruce Lodge a success. (Courtesy EMAHS.)

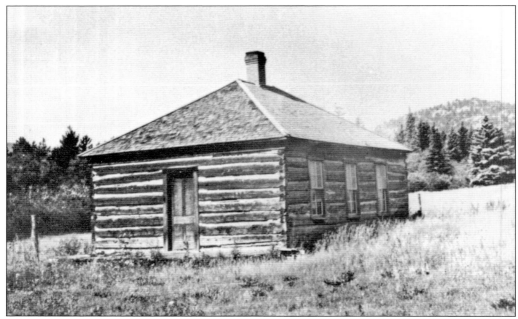

Medlen School was built of logs in 1886 by residents of the small Medlen community along South Turkey Creek. Ten years later, 34 students were attending Medlen School. Nearly one-third of them were high school age. (Courtesy EMAHS.)

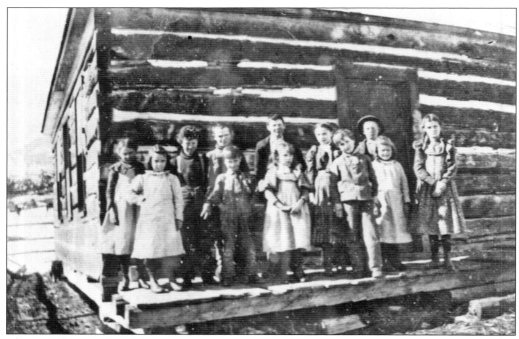

These students gathered in front of Medlen School are dressed in their best, in contrast to the school building itself. It already appears to be leaning in this late 1800s photograph, an issue that had to be addressed in more recent years. (Courtesy EMAHS.)

Medlen School was moved across the road about 1900 to escape flooding from Turkey Creek. A mudroom entryway was added, and the school was also sided over with clapboards to insulate it and present a more civilized look. (Courtesy EMAHS.)

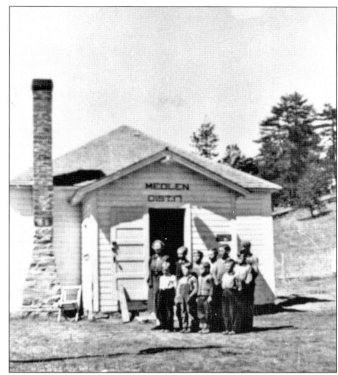

The South Turkey Creek Community Association donated Medlen School to Jefferson County Historical Society (now the Evergreen Mountain Area Historical Society) in 1992. Since then, the society has renovated the building, opened it for fun educational programs, and successfully campaigned to have it listed in the National Register of Historic Places. (Courtesy EMAHS.)

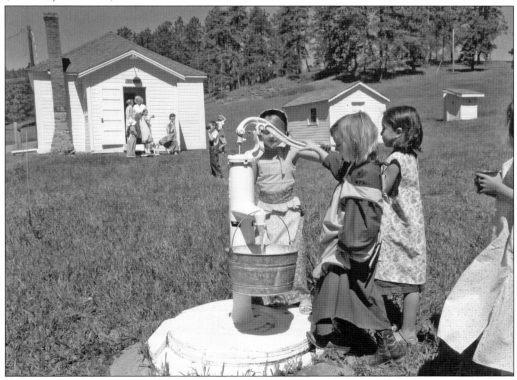

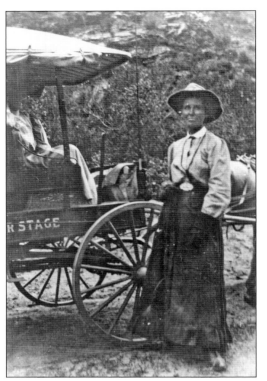

The Crow and Maple families held neighboring homesteads along Turkey Creek in the 1880s. Nearby Crow Hill is named after the Crows. After William Crow and Maggie Maple married, a post office and mail route were established in 1895, with William eventually serving as the postmaster and Maggie as the mail carrier. Here, she stands beside her mail wagon. (Courtesy EMAHS.)

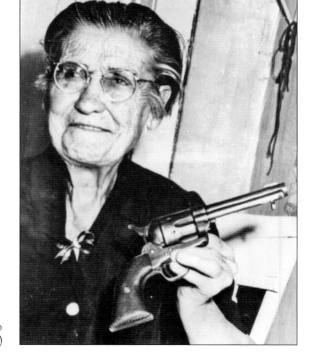

This c. 1940 photograph shows Maggie Crow posing with the trusty Colt .45 six-gun she always carried for protection. On cold days, she would heat a rock on the stove, wrap it in a towel, and sit on it in the mail wagon to keep from freezing. (Courtesy EMAHS.)

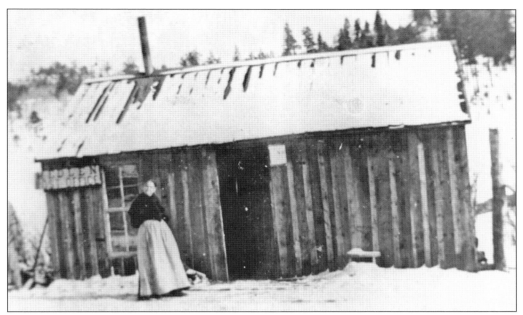

Annie Biggar poses in front of the small, primitive Medlen Post Office. Biggar was appointed interim postmistress in 1895 and was replaced by William Crow in 1896. (Courtesy EMAHS.)

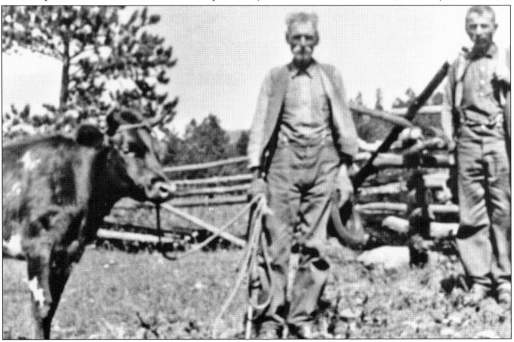

Brownsville is noted on maps of South Turkey Creek in the 1880s. The town had a population of 190 in 1882, but nothing remains today. Its most famous resident was rancher and sawmill owner Jacob "Greasy" Brown, shown here (left) with Anthony Granzella. Brown wiped his hands on his clothes while working and seldom changed clothing, leading to his nickname. (Courtesy EMAHS.)

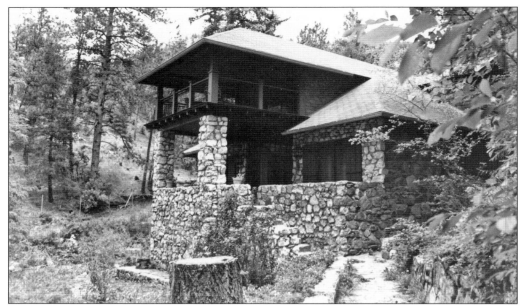

William Burkhardt, owner of an iron foundry in Denver, created his dream summer home along South Turkey Creek in the late 1920s. Known as the "Bavarian Castle" by neighbors, the five-bedroom stone chalet featured an enormous stone fireplace and hand-wrought iron fixtures. It was built over a period of three years by William, William Jr., and Libic Bowman. (Courtesy EMAHS.)

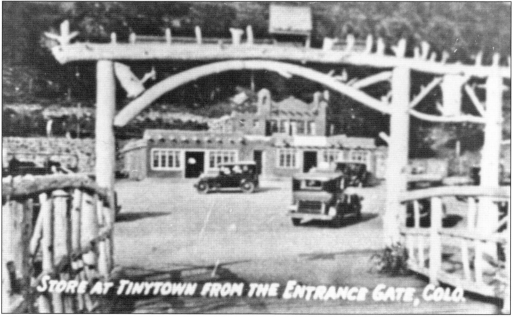

After expansion and opening to the public in 1921, Tiny Town (known at first as Turnerville) became one of the area's top tourist attractions. The creation of Tiny Town coincided with the vast expansion of automobile tourism, which sparked the creation of the Denver Mountain Parks and the beginnings of a national highway system. (Courtesy EMAHS.)

This little tyke has probably just mailed a postcard using Tiny Town's unique mailbox. Tiny Town is full of such imaginative and charming details, adding to its appeal to visitors up to the present. (Courtesy EMAHS.)

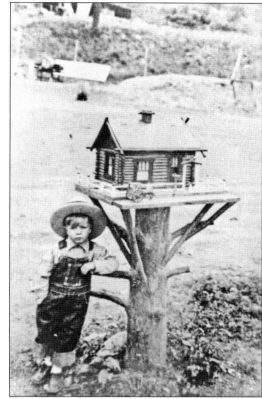

In its early years, Tiny Town boasted a full-size pueblo-style dance hall, which can be seen in the background of this photograph. Unfortunately, it burned to the ground in 1935 and was never rebuilt. (Courtesy EMAHS.)

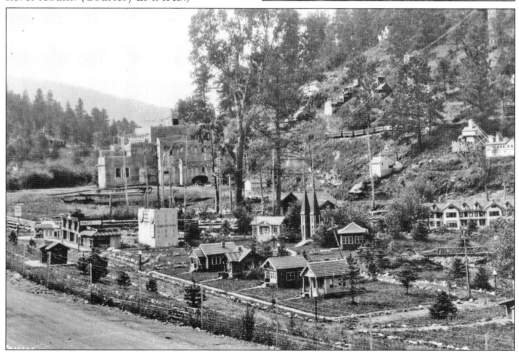

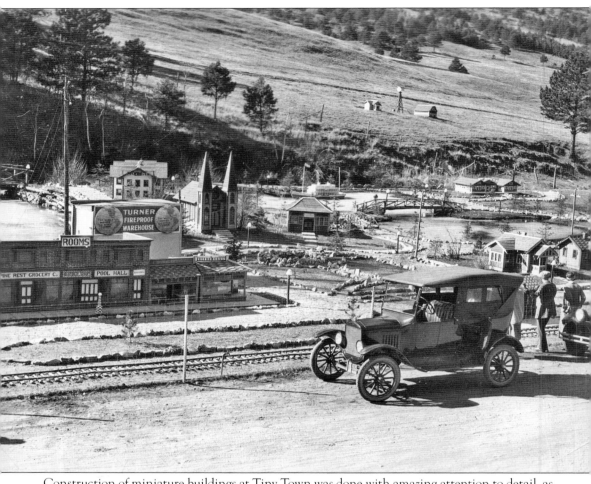

Construction of miniature buildings at Tiny Town was done with amazing attention to detail, as shown in this replica of stores and a warehouse in Denver. The tracks for the miniature railroad can be seen in the foreground. (Courtesy History Colorado, scan 10033419.)

Santino Granzella stowed away aboard ship and emigrated to America from Italy in 1882. Moving through Kansas to Colorado, he settled on a homestead claim at the headwaters of South Turkey Creek. He married Rosa Ramboz, daughter of Louis Ramboz of the Midway House, in 1887. They had seven children. The family firewood and lumber business thrived. Santino also worked as a stonemason. (Courtesy EMAHS.)

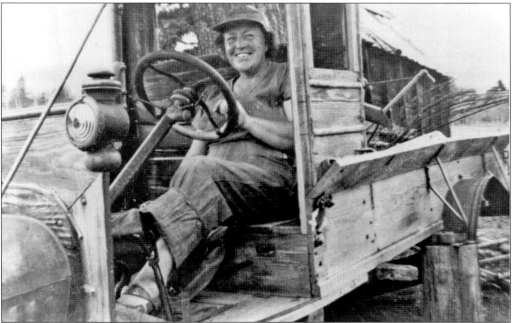

Margaret Rogers, of the Rogers family from the Oehlmann Park area, married Santino's son James Granzella in 1920, and they remained on the family ranch the rest of their lives. The old truck in which Margaret is seated may be the truck they used to haul potatoes and other vegetables for sale. In 1969, part of the movie *Downhill Racer*, starring Robert Redford, was shot on the Granzella ranch. (Courtesy EMAHS.)

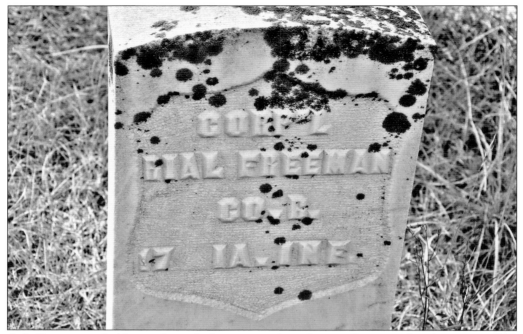

Ault Cemetery is hidden at the end of a quiet residential street. It is owned and maintained by a cemetery association board, like the Pleasant Park Cemetery. Among the burials is Civil War veteran Rial Freeman, who served as a corporal in Company B of the 17th Iowa Volunteer Infantry. He survived the war, though 194 of his fellow soldiers in the 17th Iowa did not. (Photograph by Tim Sandsmark.)

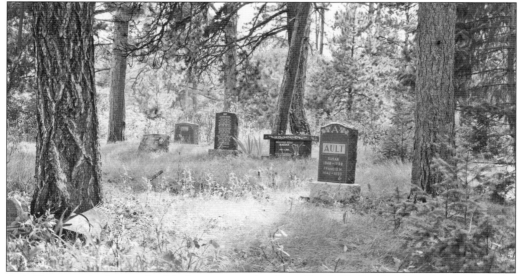

Ault Cemetery is close to the Medlen community along South Turkey Creek and was sometimes called the Medlen Cemetery. Many members of the Ault family lie buried there, along with the Maple and Crow families and others. One of the most poignant markers is that of 14-year-old Ambie Maple, who died of pneumonia in 1889 after having to cut and haul firewood in the snow. (Photograph by Tim Sandsmark.)

Six

Schaffer's Crossing and Staunton State Park

Another major junction of early pathways through the Conifer area is still a well-known crossroads. In the 1860s, as the Bradford Toll Road ran south to the gold mining areas in South Park, it crossed Elk Creek. At the crossing, a stagecoach stop known as the St. Louis House was established. A community sprang up near the crossing known successively as Willowville, Belleville, and Urmston.

Samuel and Sarah Shaffer's large family relocated to the crossing in 1902 from Wyoming, driving a large herd of horses with them. Initially buying several hundred acres, the Shaffers expanded their ranch over the years while building a large barn, home, sawmill, and general store. They may have also built a unique octagonal structure used as a dance hall, Grange hall, schoolhouse, and barn, although the structure may have been there when they bought the property. The area became known as Shaffer's Crossing.

The community continued to grow, with a hotel, general store, blacksmith, and other businesses, plus the dance hall, a Methodist Episcopal church, and a school. In the 1930s and 1940s, the dance hall was frequented by bandleader and composer Isham Jones, who lived nearby. The beautiful Elk Falls, rushing over rock formations on Elk Creek, became a tourist destination.

Shaffer's Crossing neighbors included Drs. Rachael and Archibald Staunton, who eventually owned over 1,700 acres of scenic land. They may have treated tuberculosis patients on their ranch and bartered with Native American families, offering medical treatment in exchange for handicrafts. The Stauntons' daughter, Frances Hornbrook Staunton, donated the family's land to the State of Colorado in 1986 with the provision that it would become a state park.

Additional acreage purchased for the park included land owned by the heirs of Mary Coyle Chase, author of the hit play and movie *Harvey*, and 1,000 acres of the Davis Ranch. Elk Falls Ranch, with its massive rock formations Lion's Head and Chimney Rock and the famous Elk Falls, was also added. Staunton State Park opened in 2013 to great acclaim as one of Colorado's finest state parks.

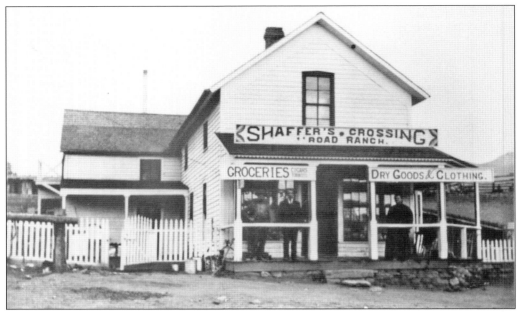

Where the Bradford Toll Road crossed Elk Creek and the Elk Creek Road, a small community grew. Previously known as Willowville, Belleville, and Urmston, the village became known as Shaffer's Crossing after Samuel and Sarah Shaffer and their six sons settled there in 1902. They also ran the local general store, shown here. (Courtesy Park County Local History Archives.)

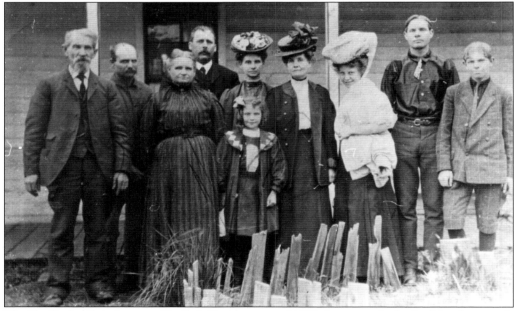

The Shaffer family is shown at Shaffer's Crossing around 1909. A note on the back of the photograph identifies them from left to right as Samuel Shaffer, Rollo Shaffer, Sarah Jane Shaffer, George Leach, Sereha Shaffer Leach (granddaughter of Sarah Aletha), Sarah Aletha Shaffer Coleman (daughter of Sarah Aletha), and John Abbott Shaffer (grandson of Sarah Aletha). Unfortunately, not all the people pictured are identified. (Courtesy EMAHS)

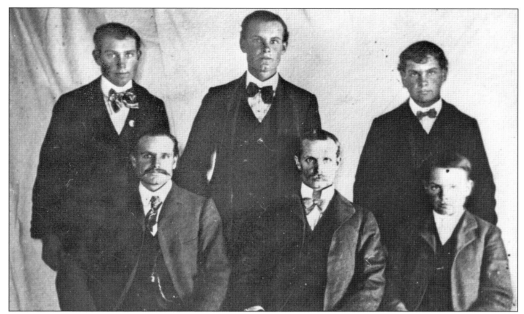

The sons of Samuel and Sarah Shaffer included, from left to right, (first row) Edward, Rollo, and Albert; (second row) Charles, Otis, and Thomas. They all helped out on the family ranch, where they raised horses and cattle, ran a sawmill, and operated the general store and hotel. The Shaffers sold off their property after Samuel and Sarah died in 1915. (Courtesy EMAHS.)

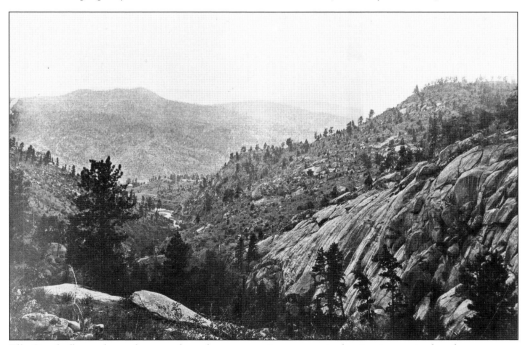

Elk Creek flows through rugged, rocky, mountainous terrain beginning at its headwaters near Mount Evans. It then flows south, emptying into the South Platte River at the town of Pine Grove. (Courtesy History Colorado, scan 10055099.)

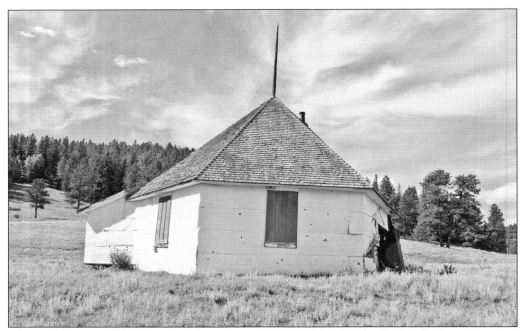

This small octagonal building may have been constructed by the Shaffer family. Over the years, it has been used as a barn, school, dance hall, and Grange hall. Its future is in doubt, and in 2018, it was named one of Colorado's most endangered structures by Colorado Preservation. (Courtesy Richard and Bonnie Scudder.)

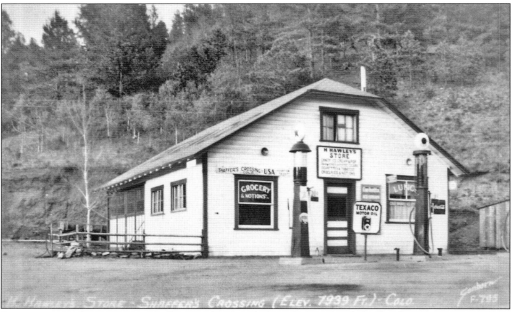

Beginning in the early 1930s, the Hawley family bought much of the land at the crossroads of the former Bradford Toll Road, then known as State Highway 8 (now US Highway 285) and Elk Creek Road. At the time of this photograph in the 1930s, only the Hawley general store can be seen at Shaffer's Crossing. (Courtesy Park County Local History Archives.)

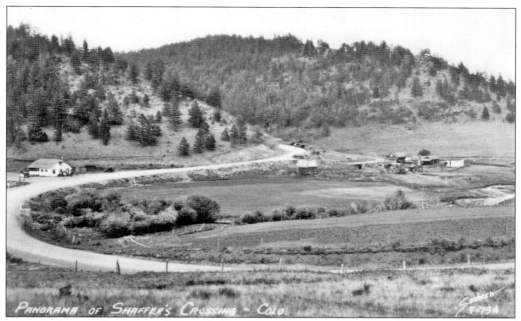

The twisting, winding route of State Highway 8 can be seen in this 1930s photograph. Although the roadway was straightened and widened after becoming US Highway 285, Shaffer's Crossing remained one of the deadliest stretches of Colorado highway until improvements were made in 2011. (Courtesy Park County Local History Archives.)

This later, expanded view shows the increased development of the Hawley general store, restaurant, gas station, and grocery store at the crossroads. It also shows part of the trout ponds, which are stocked annually and remain a popular fishing spot to this day. (Courtesy Park County Local History Archives.)

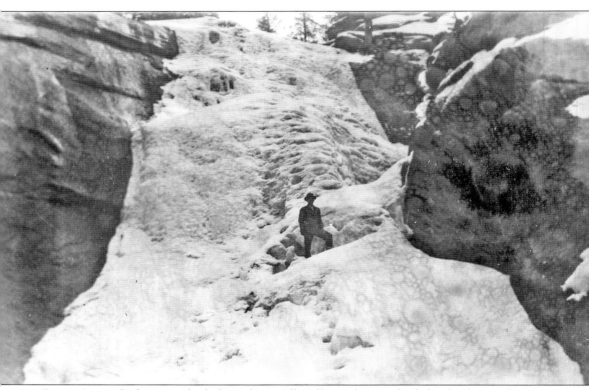

Irving Antweiler braves a climb down frozen Elk Falls. With its multiple levels of water flow over rock, Elk Falls was a picturesque destination for both local residents and tourists near Shaffer's Crossing. It remains so today as part of Staunton State Park. (Courtesy CHSM.)

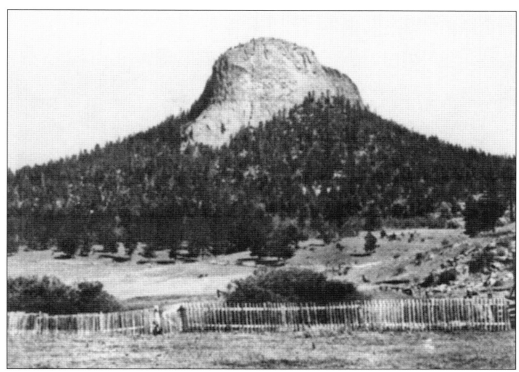

The Lion's Head is a unique mountain rock formation visible for miles around the Elk Creek area. This photograph was taken in the early 1900s from the Anton Glasmann Lion's Head Ranch. Lion's Head is now part of Staunton State Park, and several trails lead to the summit, offering spectacular views of the area. (Courtesy Richard and Bonnie Scudder.)

Possibly Shaffer's Crossing's most famous resident to date, Isham Jones was one of the country's most popular songwriters and bandleaders in the 1920s and 1930s. He wrote "It Had To Be You," "I'll See You In My Dreams," and many other great songs, often in partnership with Gus Kahn. (Courtesy Denver Public Library.)

Isham Jones built a home near Shaffer's Crossing after he retired from his bandleader career in the 1940s. He and his brother helped run the general store at the crossroads, and Jones and his musician friends would often join in to play at local dances. (Courtesy Denver Public Library.)

Dr. Archibald Staunton was on his way from West Virginia to California in 1903 in search of a drier climate to benefit his health. A stop in Denver convinced him to settle in Colorado. He and his wife, Dr. Rachael Staunton (pictured), began a medical practice and insurance business in Denver, eventually buying property along Elk Creek that became the basis for Staunton State Park. (Courtesy History Colorado, Staunton Collection, scan 10052895.)

The Stauntons' daughter Frances Hornbrook Staunton, shown here (left) riding burros with a friend around 1945, studied music at the Juilliard School and had a career as an operatic contralto and mezzo-soprano. She appeared in local opera productions as well as on KOA Radio. She donated the Stauntons' 1,720-acre ranch to the State of Colorado in 1986 to be used as a state park. (Courtesy History Colorado, Staunton Collection, scan 10020403.)

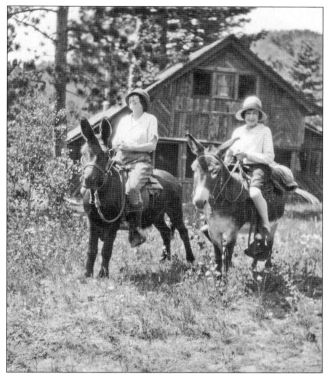

Wildwood was the two-story Staunton cabin at the Staunton ranch. Interior photographs of the cabin reveal a massive stone fireplace, a comfortable window seat with pillows and cushions, and dried herbs and flowers adorning the walls. (Courtesy Richard and Bonnie Scudder.)

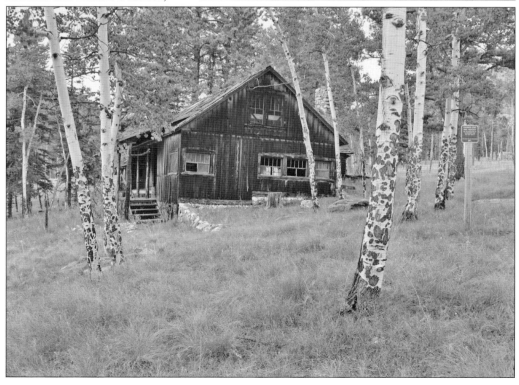

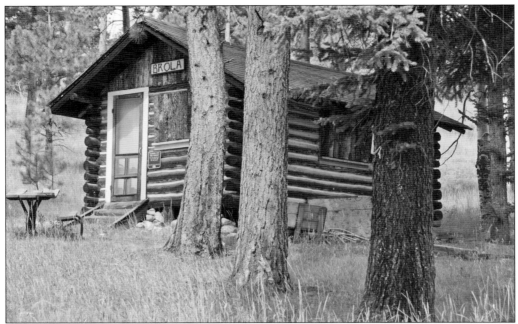

The tiny Brola cabin was used by operatic soprano Jeanne Brola (born Jeanne Lane Brooks) and her husband, John B. Harrison. A Denver native, Jeanne was known as the "Puccini Girl" due to her friendship with the composer and her starring roles in many of his works. She performed in Italy, Germany, Austria, Britain, France, and even Egypt and Australia in the early 1900s. (Courtesy Richard and Bonnie Scudder.)

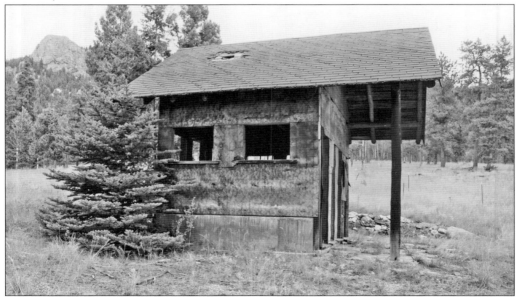

An unusually large shower house on the Staunton property leads to the supposition that the Drs. Staunton may have housed and treated some of their tubercular patients on their ranch. The fresh, clean air of the Colorado mountains beckoned tuberculosis patients and was highly recommended to foster their recovery. (Courtesy Richard and Bonnie Scudder.)

Mary Coyle Chase was the author of *Harvey*, a comedy about an invisible giant rabbit. It was hugely successful on Broadway and equally popular as a film starring Jimmy Stewart. Here, Chase and photographer Harry Rhoads celebrate at the Denver Press Club around the 1940s, with Rhoads's face covered by lipstick kisses. Some of Chase's former property has been incorporated into the acreage of Staunton State Park. (Courtesy Denver Public Library, Western History Department.)

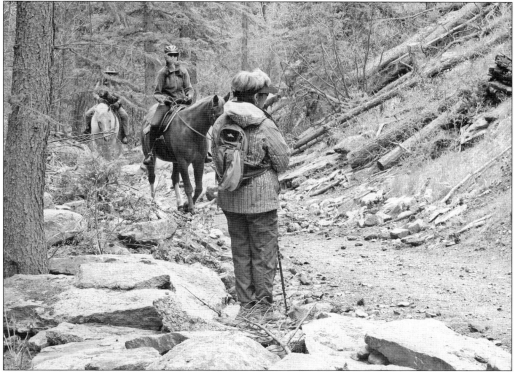

Staunton State Park offers a magnificent network of trails open to hikers, bikers, and equestrians. Although the Staunton property was donated to the state in 1986, public access to the park had to be acquired and infrastructure built before the park could open in 2013. (Courtesy Richard and Bonnie Scudder.)

During the Civil War, Confederate guerrillas known as the Reynolds Gang terrified the Elk Creek area. Before being captured or killed, they supposedly hid their looted gold in a cave. Rancher Anton Glasmann spent years obsessively searching for the gold, reportedly blasting rock from this cave trying to find it. The Reynolds Gang had no connection with the Reynolds Idle-Ease Ranch, which became Reynolds Park. (Courtesy Richard and Bonnie Scudder.)

Seven

THE 285 CORRIDOR

The Bradford Toll Road through the Conifer area was one of the busiest travel corridors in early Colorado. Even after railroads supplanted toll roads, it remained a major stagecoach route. It became Colorado Highway 8 after automobiles became common. By 1936, the route was adapted to become US Highway 285. After many expansions and upgrades, it remains the primary route through Conifer.

Duncan McIntyre founded a prosperous ranch in the 1860s along the Bradford Toll Road where he accommodated overnight travelers, harvested hay, and ran a sawmill.

Louis Ramboz from France acquired much of the McIntyre property and in 1889 constructed a spacious two-story home known as the Midway House, since it was midway between Denver and Fairplay. Legend says that P.T. Barnum's circus wintered at the ranch. In 1950, Norm and Ethel Meyer purchased the Midway House and surrounding property, naming it the Broken Bar M Ranch. They later donated much of their property to Jefferson County Open Space to create Meyer Ranch Park.

Rudolph Pollitz established an extensive ranch in 1870 along the Bradford Toll Road route. Harvesting root crops, hay, and lumber, Pollitz prospered and built a 14-room home known as the Clifton House. Later, Rudolph's stepson Charles Long and his wife, Tillithy, operated Clifton House as a stagecoach stop. It housed the local telephone exchange.

Rudy and Harlan, sons of Charles Long, built the first Long Brothers Garage about 1917 near the Clifton House. The garage later relocated to two other sites and is now the longest-surviving business in the Conifer area, with 101 years in operation.

The Fields Trading Post, another legendary Conifer business, was built by father and son George and Walter Fields in 1929. The general store and gas station was operated by the family until the 1960s, and it was leased until 1974. In 1975, it was demolished to make way for an expansion of Highway 285.

Today a new commercial area, the Conifer Town Center on Highway 285, is anchored by a Safeway store. The complex includes the lively Venue Theater, a nonprofit theater company dedicated to educating students in the theater arts.

Charles and Tillithy Long pose on horseback around 1895 in front of the Clifton House, built by Charles's stepfather Rudolph Pollitz. Charles and Tillithy made the house into a popular stagecoach stop. A handwritten newspaper, the *Rocky Mountain Boomerang*, was even distributed there in 1896 by Mabel Caton. (Courtesy Donna Long Beck.)

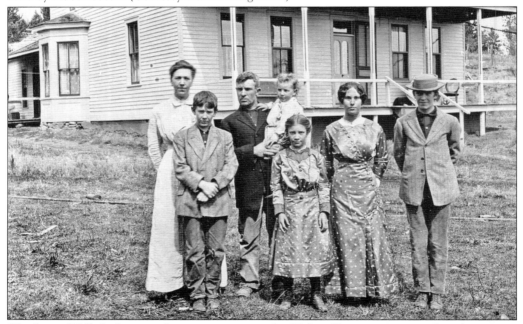

Charles and Tillithy Long made improvements to the Clifton House to accommodate their guests and growing family. They are pictured around 1913 in front of Clifton House with five of their six children (from left to right), Joseph, Maxine (held by Charles), Mary, Hazel, and Wesley. (Courtesy Donna Long Beck.)

Tillithy Long poses with her son Rudy about 1901 in front of the Clifton House. The home's many windows, spacious porches, and bay window can be clearly seen, allowing plenty of fresh air and light into the building. (Courtesy Donna Long Beck.)

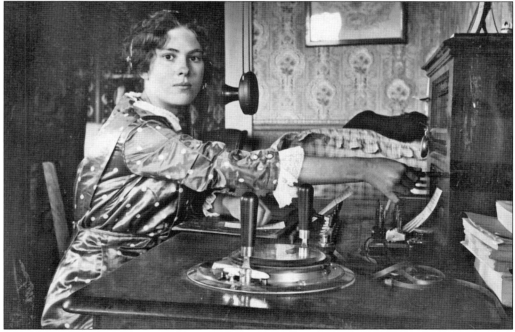

Hazel Long Fitzimmons operates the telephone switchboard in the Clifton House in this c. 1922 photograph. The local telephone exchange was housed here for some 33 years. (Courtesy Donna Long Beck.)

The dilapidated Clifton House sits among abandoned cars in this photograph taken about 1980. As the Long children grew up and started their own families in separate homes, the original family home was not lived in for many years. (Courtesy EMAHS.)

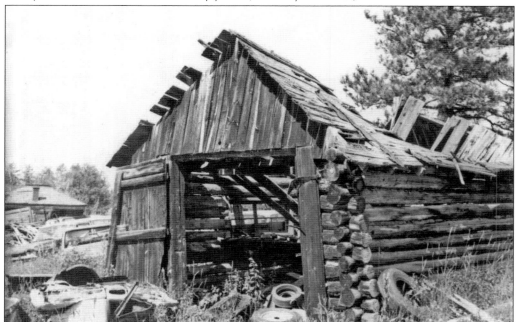

Charles, Harlan, and Rudy Long started the first Long Brothers Garage about 1917. As the business expanded, the original garage was abandoned, and two successive structures were eventually built. Clifton House can be seen in the background of this photograph. (Courtesy EMAHS.)

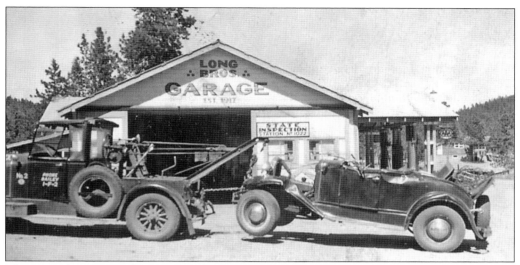

The second Long Brothers Garage location (pictured) had to be abandoned because of the widening and straightening of Highway 285, and a third garage was built. For many years, the Long Brothers Garage offered one of the few automobile repair and towing services in the Conifer area. (Courtesy EMAHS.)

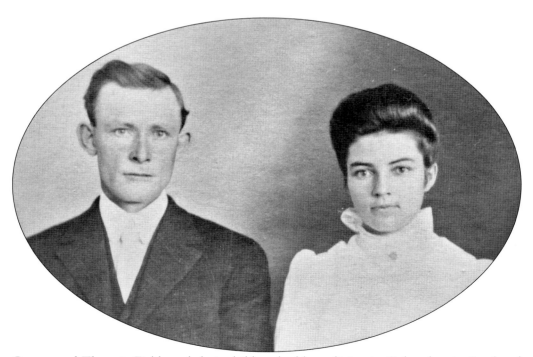

George and Theresia Fields and their children had been living in Colorado—in Berthoud and Johnstown—before moving to the Conifer area in 1918. They purchased a ranch in the Oehlmann Park area and raised their 10 children (eight girls and two boys) there. (Courtesy Donna Long Beck.)

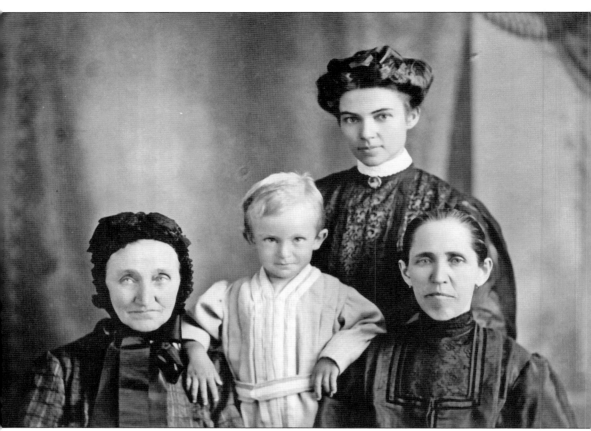

Four generations of the Fields family pose for this photograph in 1908. From left to right are great-grandmother Elizabeth Unger; Walter Fields; Walter's mother, Theresia Fields; and his grandmother Maria Hoffbauer. (Courtesy Donna Long Beck.)

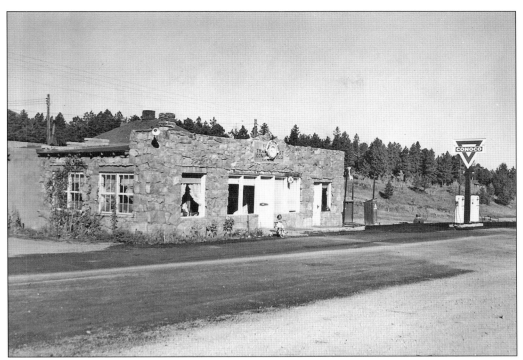

George Fields and other family members built the Fields Trading Post in 1929, later facing it with decorative stone. For many years, it served as the area's general store and gas station. One big incentive to shop there was the delicious homemade ice cream. Betty Fields Long recalls making six to nine gallons in each batch by hand. (Courtesy EMAHS.)

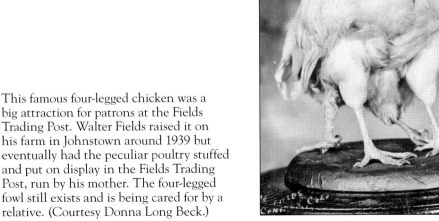

This famous four-legged chicken was a big attraction for patrons at the Fields Trading Post. Walter Fields raised it on his farm in Johnstown around 1939 but eventually had the peculiar poultry stuffed and put on display in the Fields Trading Post, run by his mother. The four-legged fowl still exists and is being cared for by a relative. (Courtesy Donna Long Beck.)

Midway House was built by Louis Ramboz in the 1880s. When the local stagecoach stop along the old Bradford Toll Road route was full of overnight lodgers, Midway House would be used for overflow lodging. The house and surrounding ranch were bought by Norm and Ethel Meyer in 1950, and they renamed it Broken Bar M Ranch. (Courtesy EMAHS.)

Norm Meyer watches in 2011 as his Cessna 180 flies away, piloted by its new owner. Meyer was a true community leader, involved in many Conifer-area organizations and also countywide groups such as the Jefferson County Historical Commission. The commission presents the annual Norm and Ethel Meyer Preservation Award in honor of the Meyers' dedication to historic preservation on their own property and elsewhere. (Courtesy Evergreen Newspapers.)

Norm Meyer was a pilot for Continental Airlines. He built a private airstrip on his ranch for his Cessna. The wind sock indicated wind force and direction for Meyer's takeoffs and landings. In 2010, he was inducted into the Colorado Aviation Hall of Fame by the Colorado Aviation Historical Society at the age of 94. (Courtesy Jefferson County Open Space.)

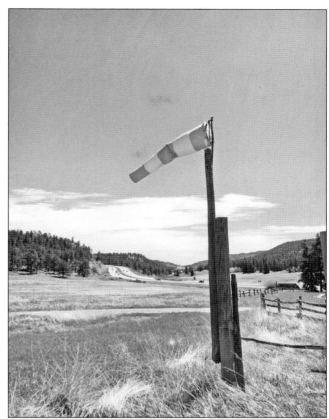

According to local legend, Louis Ramboz's huge barn, seen here, was used to winter animals from the Barnum and Bailey Circus in the late 1800s. The legend is supported by a sign that the Meyers found in the Midway House reading in part, "Circus Town, October 1889." However, there is no documentation of the Barnum and Bailey Circus appearing in Colorado in the 1800s. (Photograph by Tim Sandsmark.)

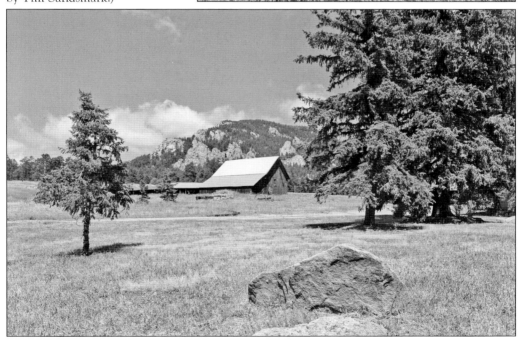

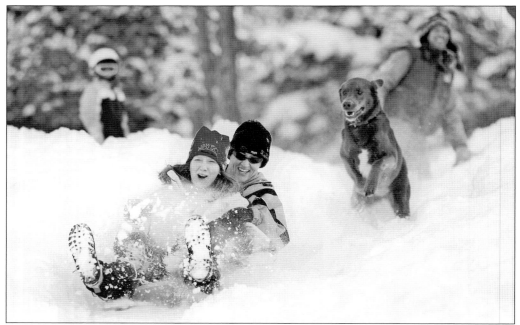

Sledding on the gentle lower slopes of Legault Mountain is one of the most popular winter activities in the Conifer area. In this 2011 photograph, Joann Paol (left) and Laura Vrba, along with dog Rusty, enjoy the great sledding at Meyer Ranch Park. (Courtesy Evergreen Newspapers.)

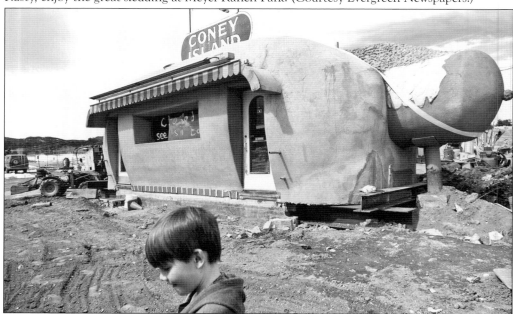

The Coney Island hot dog restaurant originally opened in Denver in 1966. "The Dog" was purchased by Jan and Beverly Slager and moved to Conifer in 1970. After being sold to new owners Ron Agner and Diane Wiescamp, it was moved to Bailey in March 2006, and Conifer lost an iconic landmark. This photograph was taken during preparations to move the building. (Courtesy Denver Public Library, Western History Department.)

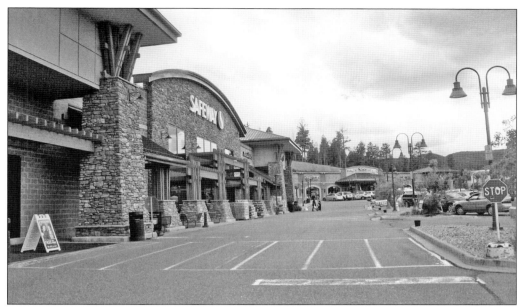

Conifer Town Center offers a variety of shopping venues, anchored by a Safeway store and pharmacy. It includes two Starbuck's cafés, a bank, Venue Theater, and a cluster of other businesses. This is in stark contrast to the past in Conifer, when residents sometimes had to travel all day to buy necessities such as food or clothing. (Photograph by John Steinle.)

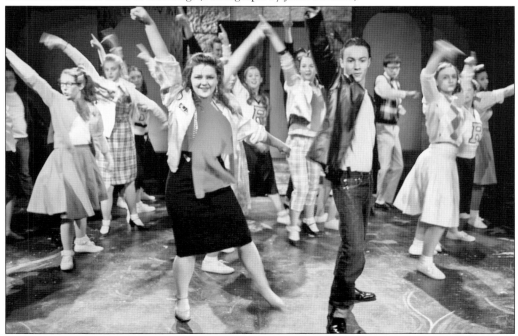

A youthful cast gives an enthusiastic performance of *Grease* in 2014 at Venue Theater in the Conifer Town Center. Venue has elementary, middle school, and high school companies. In the 2016–2017 season, an impressive 150 students participated in four productions. (Courtesy Venue Theater.)

Intensive rehearsals precede each new production at Venue Theater. Here, students prepare for a song-and-dance number in the 2015 presentation of *Into the Woods Jr.* (Courtesy Venue Theater.)

Venue Theater was founded in 2013 and has presented an amazing array of musical productions since then, such as *Annie*, shown here. The list of productions includes *Hairspray*, *Sweeney Todd*, *Mary Poppins*, *Grease*, *Les Miserables*, *Legally Blonde*, and others. (Courtesy Venue Theater.)

Eight

FOXTON ROAD AND REYNOLDS PARK

One of the fascinating aspects of public land in Jefferson County is the transformation of local ranches into parks. This holds true for much of the area along Foxton Road. The road leads from Highway 285 in Conifer down to the scenic South Platte River canyon. In 1872, when George Kennedy and his family settled on property along today's Foxton Road, they dubbed it Beaver Ranch.

The Kennedys developed a successful ranch with a sawmill, barn, outbuildings, and a comfortable house made by combining two old log prospector cabins and siding them with clapboards. Tragically, a family dispute over timber cutting and trespassing may have led to the murder of George Kennedy's son John, shot in 1891 while riding in a wagon with his father. The culprit may have been George's brother-in-law Silas Ellis, but this was never proven. The Kennedys sold Beaver Ranch to the Bennett family in 1895 and moved away.

Beaver Ranch eventually boasted a post office, popular dance hall, hotel, and general store. James Quigg Newton, father of Denver mayor James Quigg Newton Jr., bought Beaver Ranch. The Methodist Church founded a summer camp for boys there, later funded through the Kiwanis. The YMCA bought the property in 1995 and ran it as a year-round camp for boys and girls. By the early 2000s, the Beaver Ranch property was divided between Denver Mountain Parks and Jefferson County Open Space.

Foxton Road leads to another gem of the Jefferson County Open Space system, Reynolds Park. John Reynolds and his wife had been in show business before deciding to develop a dude ranch. The couple made a homestead claim, later buying adjacent property to create an 1,100-acre ranch. Starting in 1913, they hosted guests on their Idle-Ease Ranch. There were 14 cabins on site, some remaining from a previous Mormon settlement. Gas rationing during World War II put an end to the dude ranch. In 1975, Dell Reynolds, John Reynolds's second wife, donated the land to Jefferson County Open Space, creating one of the most beautiful parks in the entire region.

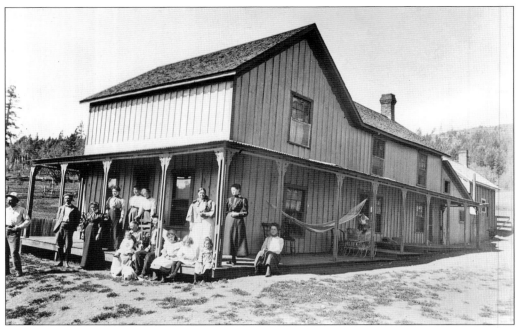

Beaver Ranch, located along the Bradford Toll Road route, was settled in the early 1860s by the George O. Kennedy family. After the unsolved murder of George Kennedy's son John in 1891, the Kennedys sold Beaver Ranch to the Bennett family and moved away. This photograph probably shows the Bennett family in the 1890s at the original Beaver Ranch house. (Courtesy Denver Public Library, Western History Department.)

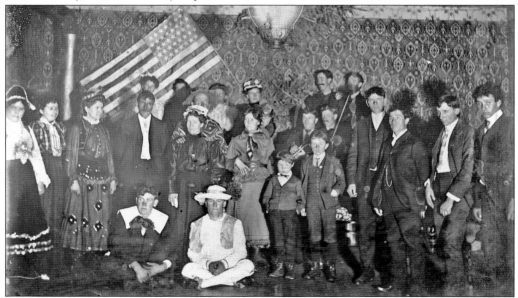

In this 1899 photograph, guests at Beaver Ranch enjoy a masquerade dance. Longtime resident Glenn Gray recalled the complex at Beaver Ranch including a general store, hotel, post office, and barn. He remembered special occasions including holiday celebrations, dances, rodeos, and prize fights. (Courtesy Denver Public Library, Western History Department.)

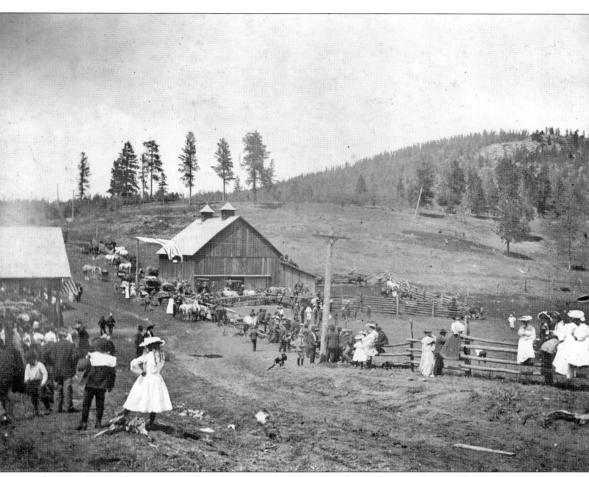

The popularity of Beaver Ranch is shown in this photograph of a large gathering there in 1904 to celebrate the Fourth of July. The big, distinctive barn in the background is still in place along Foxton Road and Highway 285. (Courtesy Denver Public Library, Western History Department.)

This photograph was taken after a baseball game between Conifer and Pine Grove at Beaver Ranch on July 4, 1905. The defeated Pine Grove team sits in the foreground, while the Conifer team stands behind. Conifer team members are, from left to right, Leon Boswell, Ralph L. Hobbs, Glen Dow, Walter Dow, John Hockings, Ed Shaffer, and Carl Kuehster. (Courtesy Denver Public Library, Western History Department.)

Today the Beaver Ranch property is divided, with the eastern part operated as James Q. Newton Park by Denver Mountain Parks and the western part, known as Conifer Community Park, owned by Jefferson County Open Space and operated by a separate nonprofit, Beaver Ranch Community. (Photograph by Tim Sandsmark.)

Conifer Community Park offers a variety of venues for weddings and family events, disc golf, zip lining, and a wooded outdoor chapel. Added to this are miles of hiking trails offering spacious views of the surrounding mountains. In this photograph, Lukas Guennel, a guide with Denver Adventures, tightens a zip line cable at Beaver Ranch. (Courtesy Evergreen Newspapers.)

Conifair was held at Beaver Ranch for several years starting in 2000. The first event attracted more than 7,000 people and was a fundraiser for the victims of the recent, devastating Hi Meadow Fire. Multiple bands played over the course of two days, and a variety of activities were offered. This was one of the first community-wide festivals held in Conifer. (Courtesy Conifer Area Chamber of Commerce.)

The original ranch house at Reynolds Park was the home of the Reynolds family when their dude ranch was known as the Idle-Ease Ranch. At its height, the Reynolds ranch operation included four guest cabins built by John Reynolds, plus 10 cabins reportedly built by a group of Mormons. The Reynolds home is now occupied by a live-in Jefferson County Open Space ranger. (Photograph by Tim Sandsmark.)

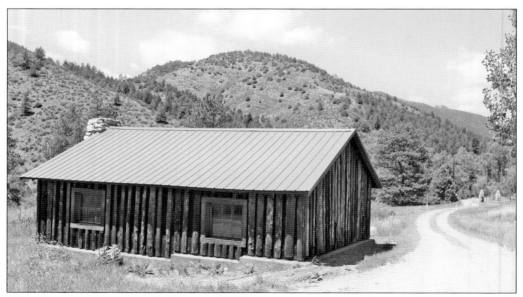

This cabin was nicknamed the "dance hall." Though its interior is small, it is said that the Reynolds family held dances for their guests in it on Saturday nights. On summer Sundays, hot dog suppers were offered on the bank of nearby Casto Creek. Guests could also enjoy riding, hunting, fishing, hiking, or just relaxing. (Photograph by Tim Sandsmark.)

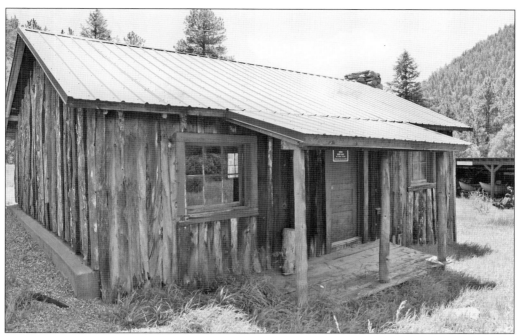

The only surviving individual guest cabin still has a sink and plumbing inside. Jefferson County Open Space workers have put new roofs on the buildings and maintain them as reminders of the Idle-Ease dude ranch history. (Photograph by Tim Sandsmark.)

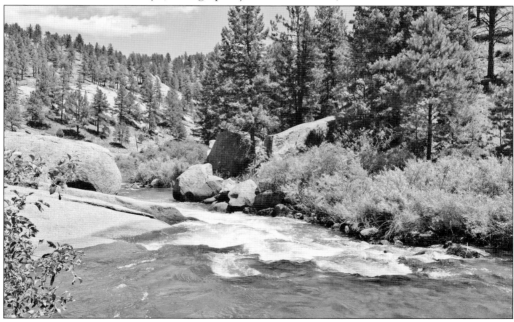

Foxton Road leads to the magnificent South Platte River canyon. At one time, the Denver, South Park & Pacific Railroad (later the Colorado & Southern) tracks ran along the riverbed. Now the roadway running over the old railroad grade offers great opportunities for fishing. (Photograph by Tim Sandsmark.)

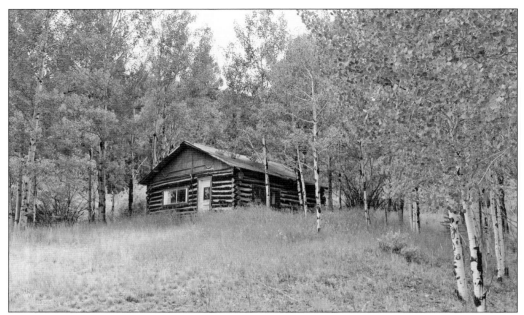

The Foxton community was originally known as Park Siding and was a stop along the railroad route. By 1904, an English family, the Roaches, bought the property and renamed it Foxton. Convenient rail travel from Denver led to development of a small summer cabin community. Some of the summer cabins remain, many of them owned by the original families. Foxton was a railroad stop until 1927. (Photograph by Tim Sandsmark.)

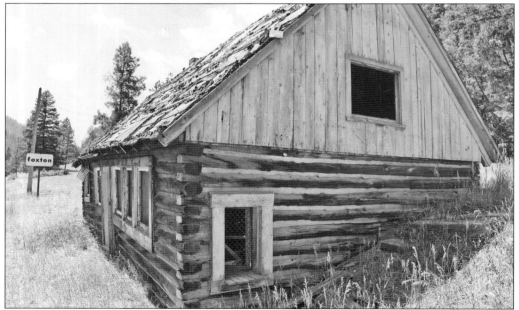

The old Foxton general store and post office remains, although it has been abandoned for many years. In 2002, it was added to the most endangered buildings list by Colorado Preservation. Since then, there have been discussions with the owner, Denver Water Board, about preserving the building, but no action has been taken. (Photograph by Tim Sandsmark.)

Nine

Pillars of the Community

In Conifer's earliest days, schools, churches, the local Grange hall, and other public facilities were built with totally volunteer labor and inspired by the concerns of local families. The relatively isolated nature of the Conifer area made it imperative that community improvements be created by the local citizens themselves.

After World War II, growth in the Conifer population and improved travel and communications made it possible for new community support organizations to arise.

The Elk Creek Fire Protection District was organized in 1948 to provide fire and emergency protection for the area after residents were frustrated by a disastrous fire. At first, the fire department used surplus World War II vehicles and equipment and was all-volunteer. The department still relies mostly on volunteers to protect Conifer citizens, responding to more than 1,200 emergency calls each year. The district now covers 98 square miles, protecting an estimated 15,000 people.

Conifer grew exponentially during the 1970s, and the Conifer Area Chamber of Commerce was founded in 1975 to promote local businesses and provide networking opportunities. The chamber also helps sponsor and publicize many well-known local events and festivals, among them the Conifer Christmas Parade, the summer Elevation Celebration, and the OctoBEERfest.

The nonprofit Mountain Resource Center was organized in 1990, providing vital goods and services. The center offers services for veterans, a resale store, family education, food and gas vouchers, a food pantry, rent and mortgage help, and other means of assistance to those in need of a helping hand.

Conifer Rotary and Kiwanis service clubs offer scholarships, grants, volunteer projects, and other support for school and nonprofit groups in the Conifer area.

In 2009, Conifer Historical Society and Museum was founded as a nonprofit volunteer organization. In 2012, CHSM gained a home base with the donation of the Conifer Junction School by the Jefferson County School District. CHSM now sponsors many historical programs at the old school, known as the Little White Schoolhouse, connecting the people of Conifer with their heritage.

Bringing Conifer history full circle, the Pleasant Park Grange, Conifer's oldest community organization, still thrives today.

The original Elk Creek Fire Protection District station is shown in this 1950 photograph. Volunteers built the station in 1948 on land provided by the Long family for $10. After a new station was built in 1963, Rudy and May Long used it for their ambulance service. On June 8, 2007, an out-of-control semi-truck slammed into the original fire station, destroying it. (Courtesy Donna Long Beck.)

As part of recruit training, an Elk Creek Fire Protection District firefighter lights a live fire during burn building training at the nearby Platte Canyon fire station. Burn buildings or towers are designed to provide training for firefighters, who must enter burning structures to fight the flames. (Courtesy Evergreen Newspapers.)

In 2009, Elk Creek Fire Protection District firefighter Loren Schuessler helps Cherakee Anderson at the Conifer Safety Fair. Besides fire safety training, the district provides free community chipping to process underbrush, trees, and branches that have been cleared to provide defensible space around buildings. (Courtesy Evergreen Newspapers.)

Conifer Rotary is deeply involved in promoting literacy throughout the community. Here, Wendy Woodland, principal of West Jefferson Elementary School, accepts a check from Rotary to help promote literacy at the school. The students display the books they are currently reading. (Courtesy Evergreen Newspapers.)

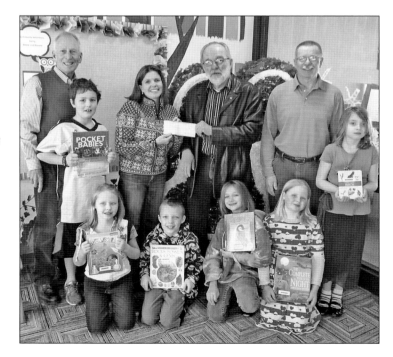

Rotarians Mike Daniels, his dog Bear, and Big-O-Tire owners Beth and Jerry Schroppel volunteer as Salvation Army bell ringers at Christmastime. Most members of the Conifer Rotary volunteer annually to help with bell ringing, supporting the Salvation Army's charitable efforts. (Courtesy Evergreen Newspapers.)

In 2013, Dr. Joe Wheeler presents one of his books to a third-grade student at the annual Kiwanis Reading Program celebration. Dr. Wheeler has written or edited nearly 100 books, among them a series of 26 uplifting Christmas anthologies entitled *Christmas In My Heart*. Each year, he donates a copy of one of his books to each third-grader in the Kiwanis Reading Program. (Courtesy Evergreen Newspapers.)

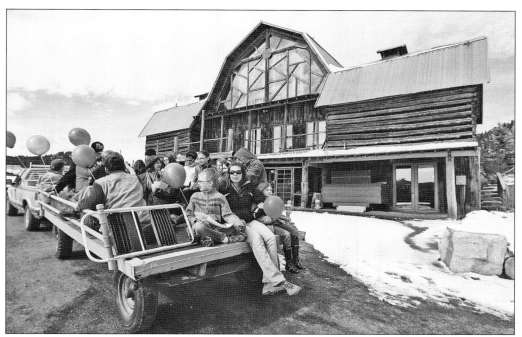

Students enjoy a hayride at the annual Kiwanis Reading Program celebration. More than $10,000 has been donated by Conifer Kiwanis to local elementary school to boost literacy and help with their reading programs. One of the mottos of Kiwanis International is "It's All about the Kids." (Courtesy Evergreen Newspapers.)

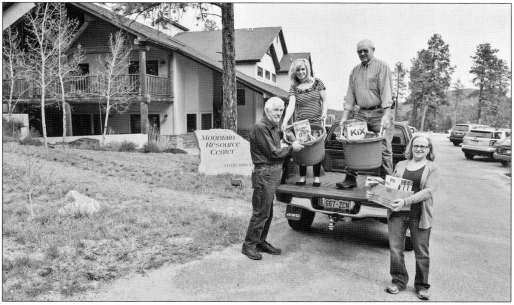

Volunteers unload a shipment for the food pantry at the Mountain Resource Center in Conifer. For more than 25 years, the center has provided food, clothing, counseling, and other services for Conifer and the surrounding area. Nearly 300 volunteers donate their time to help the center's efforts. (Courtesy Mountain Resource Center.)

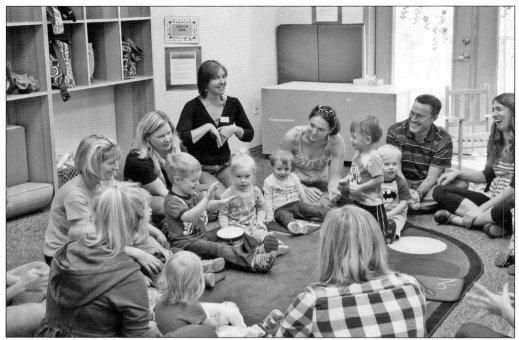

The Mountain Resource Center offers free classes in early childhood development and parenting support for families. The parents or caregivers and children attend together. The current classes include Discovery Time Drop-In, Healthy Living and Early Literacy, Nurturing Parenting, and Parenting Book Club. (Courtesy Mountain Resource Center.)

Demonstrating their artistic talent, supporters of the Mountain Resource Center paint decorative bowls to be given away as souvenirs at the center's three main fundraising events, the Bowls After Dark Evening Gala, the Mountain Bowls Luncheon, and the Mountain Bowls dinner. The entrance fees and other fundraising techniques are used at these events to support the Mountain Resource Center's community activities. (Courtesy Mountain Resource Center.)

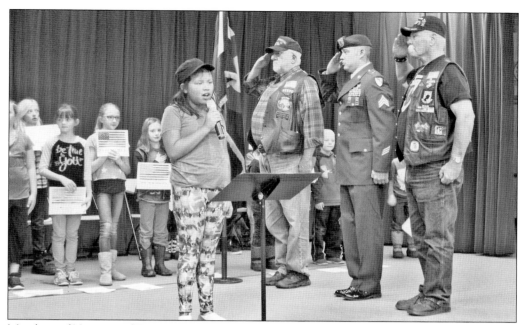

Members of Veterans of Foreign Wars Post 12009 stand at attention as Lucinda Altman sings the national anthem. The VFW members attended as part of a West Jefferson Elementary School event honoring the US military in 2015. (Courtesy Evergreen Newspapers.)

VFW Post 12009 member Rocco Biernat makes pancakes at the VFW-sponsored all-you-can-eat breakfast at Beaver Ranch. Post commander Kirk Rosa helps in the background. The community breakfasts are attended by as many as 300 people and are held the third Sunday of each month. (Courtesy Evergreen Newspapers.)

Members of Conifer Historical Society and Museum bring the history of Conifer to life for the community. Here, they portray members of the Kemp family buried in the Kemp Cemetery in Conifer. From left to right are Carla Mink, Lin Rudy, Stephen Rudy, Suzi Morris, and Donna Long Beck. (Courtesy Suzi Morris.)

From left to right, Conifer Historical Society and Museum volunteers Pat Webers, Chris Baumann, and Paul Palmer help with the cooking at the annual membership barbecue at the Little White Schoolhouse. Frequent events at the schoolhouse ensure a broad range of community support. (Courtesy Suzi Morris.)

Jefferson County sheriff Ted Mink stands in front of the newly acquired Ford Interceptor patrol car in 2012. The Jefferson County Sheriff's Department was the first law enforcement agency in Colorado to deploy these advanced vehicles. The department provides law enforcement for unincorporated Conifer County. (Courtesy Evergreen Newspapers.)

Astronaut Bruce McCandless lived in Conifer during the latter part of his life until his death in 2017. McCandless was the first to move untethered in space during a space shuttle mission in 1984 using a manned maneuvering unit. He served on the 1990 space shuttle *Discovery* mission that deployed the Hubble Space Telescope. In this photograph, he dons a spacesuit to assist with the Hubble deployment. (Courtesy NASA.)

Planning Pleasant Park Grange activities, members of the Pleasant Park Grange Executive Board meet at the Grange hall. Clockwise from left are Yvonne Ludwig, master (standing); Donna Long Beck, treasurer; Don Morris; Suzi Morris; Sharon Minick; and Harlan Helker. (Courtesy Donna Long Beck.)

Kendall Spoor, at far left, led the 2018 Eagle Scout project at Pleasant Park Grange along with members of Boy Scout Troop 686. The Scouts installed a bear-proof trash container and refinished picnic tables at the bicycle rest stop. (Courtesy Donna Long Beck.)

Two true pillars of the community whose families helped create Conifer and have contributed to its development for well over a century are Betty Fields Long and Bob Kuehster (Larry Bonomo is in the background). Betty and Bob have been lifelong members of the Pleasant Park Grange, which their families helped found in 1907. Both attended the Pleasant Park School. Bob recalls that when he was in first grade, Betty was in second grade sitting in front of him by the wood stove. (Courtesy Suzi Morris.)

BIBLIOGRAPHY

Bentley, Margaret V. *Aspen Park: A History of Aspen Park Subdivision and Aspen Park Improvement Association*. Conifer, CO: 1980.

———. *The Upper Side of the Pie Crust: An Early History of Southwestern Jefferson County Conifer–Pine–Buffalo Creek, Colorado*. Evergreen, CO: Learning Pathways, 1978.

Crain, Mary Helen. *A Circle of Pioneers*. Tri-Canyon Publishing Co.

Crofutt, George. *Crofutt's Grip-Sack Guide of Colorado*. Omaha, NE: Overland Publishing Company, 1881.

Granzella, Phebe. *A Century of Jefferson County Mountain Area Schools*. Golden, CO: Jefferson County Historical Commission, 1993.

Hayden, F.V. *Geological and Geographical Atlas of Colorado and Portions of Adjacent Territory*. Julius Bien, lithographer. Washington, DC: Department of the Interior, 1877.

Kilgore, Hermina Gertrude. *Rough Road in the Rockies: Ups and Downs of Log-Cabin Life on a Fox Farm*. Colorado Springs, CO: Century One Press, 1961.

Moynihan, Betty, and Helen E. Waters, eds. *Mountain Memories: From Coffee Pot Hill to Medlen Town, A History of the Inter-Canyon Area of Southwest Jefferson County*. Lakewood, CO: Limited Publications, 1981.

Nelson, David. *The Elk Creek Chronicles, from Shaffers Crossing to Pine Grove*. Littleton, CO: ReVista Publishing, 2011.

Scudder, Bonnie. *The Secrets of Elk Creek: Shaffers Crossing, Staunton State Park and Beyond*. Pine, CO: Elk Creek Publishing, 2013.

Simmons, Beth. *Colorow! A Colorado Photographic Chronicle*. Golden, CO: Jefferson County Historical Commission and Friends of Dinosaur Ridge, 2015.

Warren, Harold. *Bits and Pieces of History Along the 285 Corridor, from Denver to Kenosha Pass*. Bailey, CO: KR Systems, 1994.

INDEX

Discover Thousands of Local History Books Featuring Millions of Vintage Images

Arcadia Publishing, the leading local history publisher in the United States, is committed to making history accessible and meaningful through publishing books that celebrate and preserve the heritage of America's people and places.

Find more books like this at
www.arcadiapublishing.com

Search for your hometown history, your old stomping grounds, and even your favorite sports team.